THE SECOND WORLD WAR

IN PICTURES

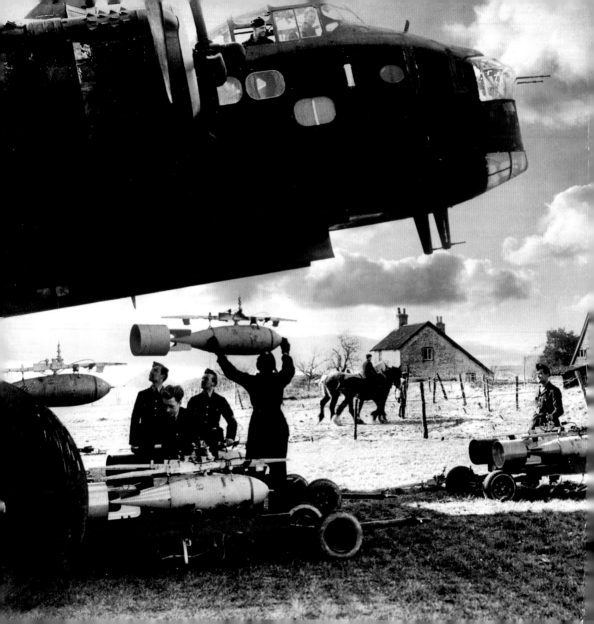

THE
SECOND
WORLD
WAR
IN PICTURES

AMMONITE
PRESS

First published 2013 by
Ammonite Press
an imprint of AE Publications Ltd,
166 High Street, Lewes, East Sussex, BN7 1XU

Text © AE Publications Ltd, 2013
Images © Mirrorpix, 2013
Copyright © in the work AE Publications Ltd, 2013

ISBN 978-1-90770-889-3

British Cataloguing in Publication Data. A catalogue record of this book is available from the British Library.

Editors: Ian Penberthy, George Lewis
Series Editor: Richard Wiles
Design: Robin Shields
Picture research: Mirrorpix
Colour reproduction by GMC Reprographics
Printed in China

Page 2
A Royal Air Force ground crew loads bombs on to a Short Stirling bomber while a farmer goes about his daily toil.
3rd April, 1942

Page 5
British troops laugh as they are entertained by a concert party. They were in Sussex, waiting to cross the Channel to join the British Expeditionary Force. This was during a period known as the 'Phoney War', when nothing much was happening on the military front; before long, there would not be so much to laugh about.
1939

Page 6
Elsie Smith is rescued from the remains of her home in east London after it was demolished by a German V1 flying bomb.
24th July, 1944

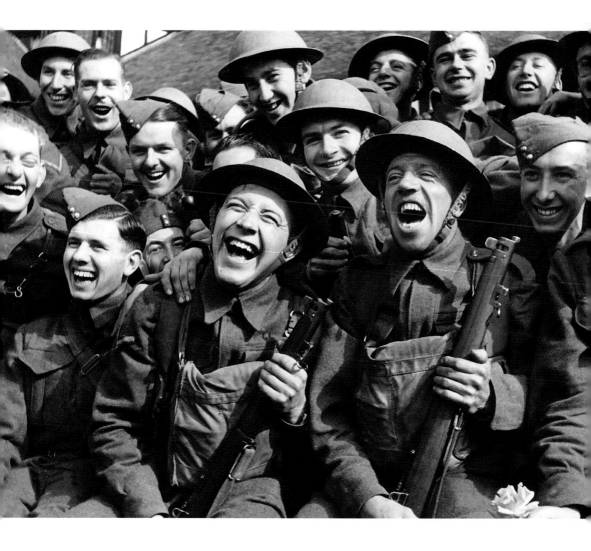

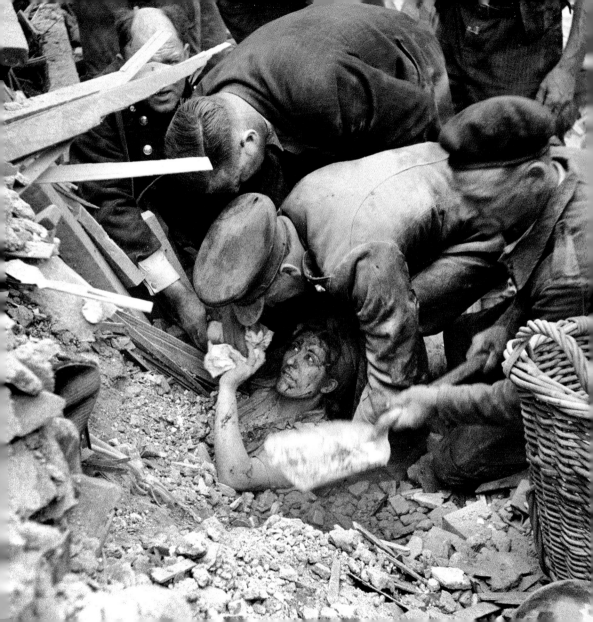

INTRODUCTION

Only 20 years after the First World War, the "war to end all wars", the Second World War broke out in Europe in 1939 and spread rapidly around the globe, involving most of the world's nations and all of the great powers, who formed two opposing military power blocs: the Allies and the Axis. The former were led by the United Kingdom, the United States and the Soviet Union; the primary members of the latter were Germany, Italy and Japan. The war raged until 1945, when the first use of nuclear weapons in warfare (the atomic bomb by the Americans) finally brought an end to the conflict with the last remaining Axis power, the Japanese, in the Far East.

The most widespread war in history, the Second World War involved more than 100 million people who served in military units. Moreover, the major participants adopted a state of 'total war' whereby the nation's entire economic, industrial and scientific capabilities were dedicated to the war effort, removing the distinction between military and civilian resources. The widespread use of strategic bombing by both sides saw civilians targeted in their homes and at their workplaces, particularly in Britain, Germany and Japan, leading to substantial death tolls. Moreover, mass exterminations of civilian populations by Germany and Japan produced a total number of fatalities that some estimates suggest reached 50 million, while others say that the number could be more than 70 million. It was the deadliest conflict in human history.

Legacies of the war include the establishment of the United Nations and the European Union to encourage international co-operation and prevent future conflicts, and the rise of the United States and Soviet Union as rival superpowers, leading to the Cold War, which lasted for nearly half a century.

This book looks at the Second World War from a largely British perspective, based on almost 300 photographs from the archives of Mirrorpix.

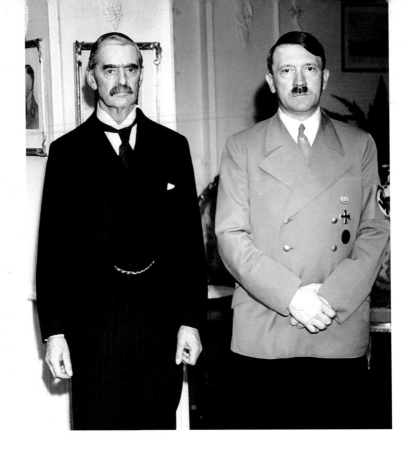

Having engineered the annexation of Austria in early 1938 in his attempt to build a Greater German Reich, German Chancellor Adolf Hitler (R) turned his attention to the Sudetenland, an area of Czechoslovakia with a large ethnic German population. Fearful of Europe being tipped into war again, Britain, France and Italy agreed to Hitler's demands at a conference held in Munich in September, 1938 (against the wishes of the Czechoslovak government, who had not been invited). Prime Minister Neville Chamberlain (L) signed the agreement on Britain's behalf. **29th September, 1938**

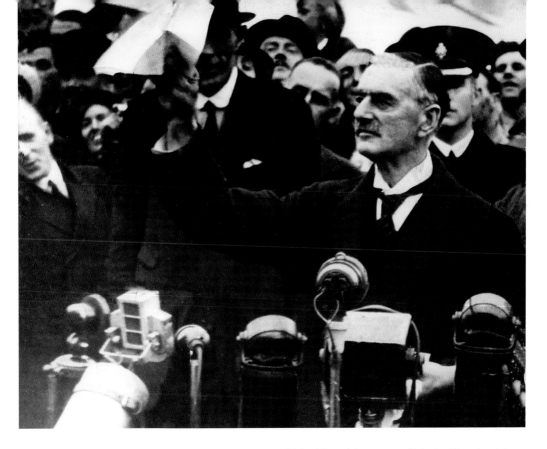

Right: Upon his return to Britain, Chamberlain brandished the Munich Agreement to the waiting press, later saying, "I believe it is peace for our time." His words would return to haunt him.

3rd October, 1938

Emboldened by his success, Adolf Hitler seized more territory in Czechoslovakia and turned his attention to Poland. In response, Britain and France guaranteed Polish independence. With international tensions rising, gas masks were issued to the civilian population. Here a mother attends the demonstration of a special baby's respirator.

25th August, 1939

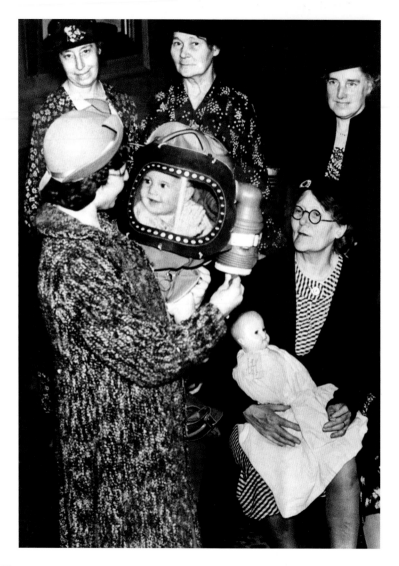

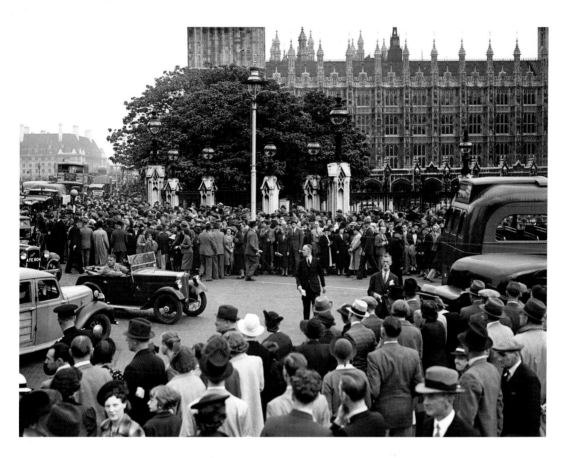

On 1st September, 1939, Germany attacked Poland; two days later, Britain and France declared war on Germany. After the Prime Minister's radio announcement, large crowds gathered outside the Houses of Parliament and in Downing Street hungry for news.

3rd September, 1939

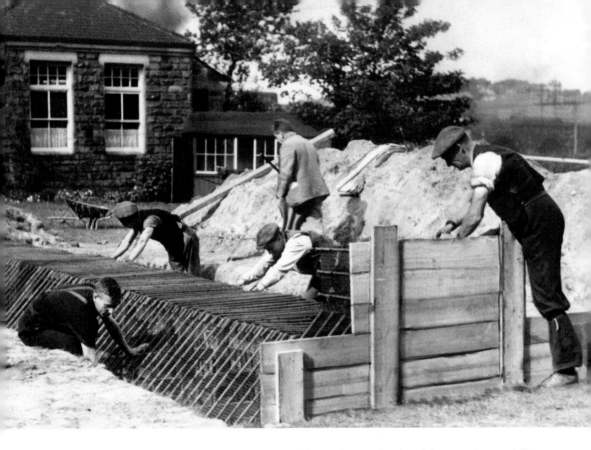

In the late 1930s, German aircrews had carried out devastating bombing attacks on civilian populations during the Spanish Civil War, and it was expected that they would do the same over Britain – a million casualties were anticipated in the first month of war alone, although fortunately the effects of bombing proved to be subtantially over-estimated. Consequently, work began on a variety of air raid precautions, including the construction of underground shelters, such as this one being built in Durham.
September, 1939

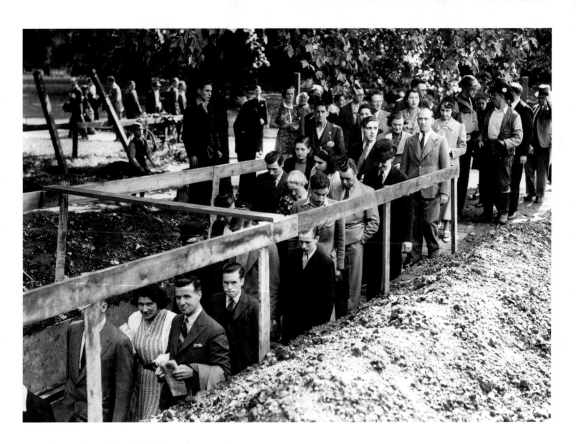

Crowds make their leisurely way down to a newly constructed underground shelter as the air raid siren sounds minutes after war is declared. It turned out to be a false alarm.
3rd September, 1939

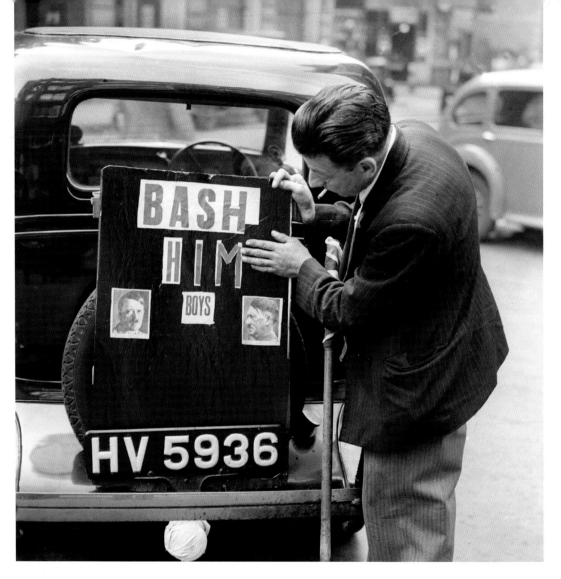

Left: A driver advertises his support for the British armed forces on the day after war was declared.

4th September, 1939

Right: On the day after the declaration of war, Scotland's *Daily Record* concentrates on the news of Nazi atrocities carried out in Poland. After the widespread use of poison gas in the First World War, it was expected that it would be used against civilians. In fact, this fear never materialised.

4th September, 1939

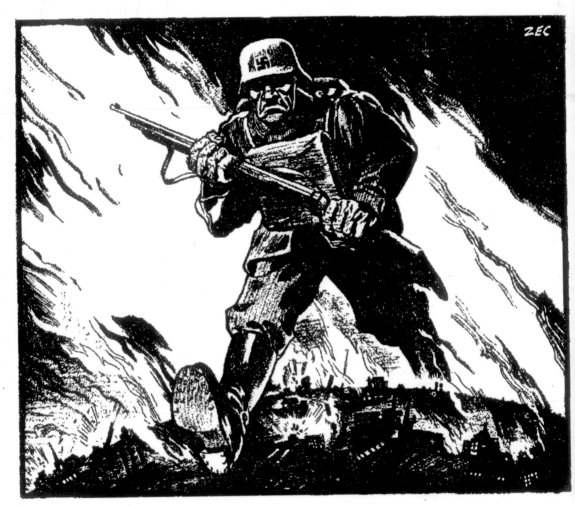

Strength—Through Joy!

Left: A Philip Zec cartoon from the *Daily Mirror* contrasting the 'Strength through Joy' motto of the German Nazi party with the violence of Germany's expansionism under that party, led by Adolf Hitler. Zec abhored fascism, and his work reflected that hatred. It was said that his name was on a list of people who would have been arrested had the Germans been successful in invading Britain.
18th September, 1939

Right: A British soldier kisses his child goodbye as he leaves for France to join the British Expeditionary Force. With the German Army occupied in Poland, however, there would be very little military activity until German troops marched into Belgium, the Netherlands and Luxembourg in May 1940.
5th October, 1939

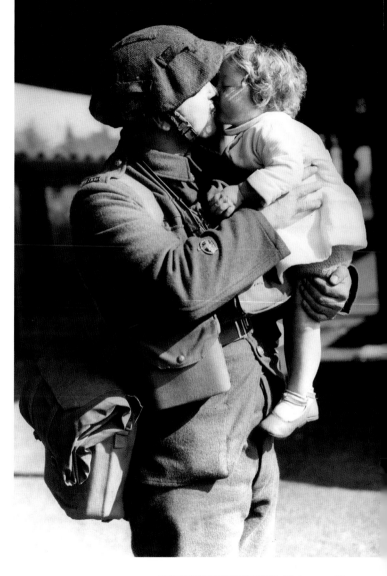

Left: A major air-raid precaution in Britain was the blackout, it being forbidden to show lights at night in case they were used as navigation aids by German bombers. Car headlamps were fitted with shields that directed the light beams downwards.
24th October, 1939

Right: As part of the blackout, windows had to be fitted with heavy curtains or screens to prevent escape of light at night. This house in Brixton, south London, has a rather artistic interpretation of the requirement.
16th November, 1939

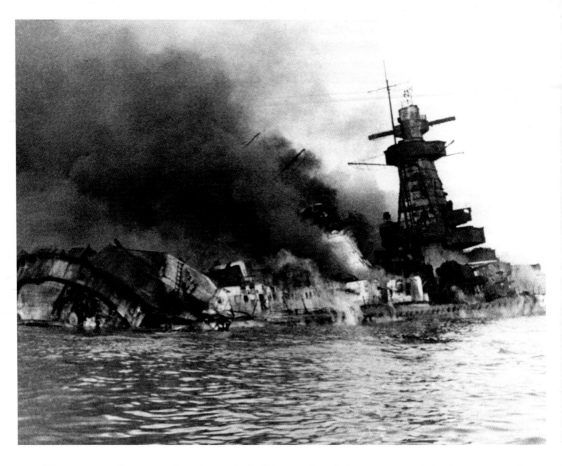

The German heavy cruiser *Admiral Graf Spee* after being scuppered by her crew off Montevideo, Uruguay. She had put into the port after being damaged by British warships during the Battle of the River Plate. Convinced that superior British forces were waiting out to sea, her captain, Hans Langsdorff, ordered the scuttling. The next day, he shot himself.
18th December, 1939

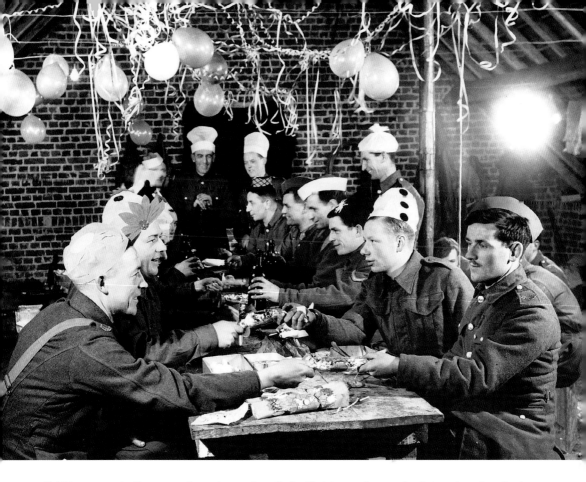

British troops in France pull crackers after their Christmas dinner. At that point, they had seen no action and would not do so for several more months. Only Britain's Royal Navy was experiencing regular contact with the enemy.

24th December, 1939

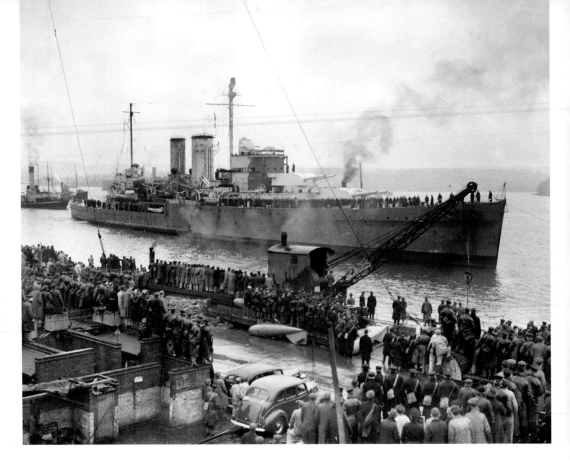

The Royal Navy's heavy cruiser HMS *Exeter* returns to Plymouth for a full refit after sustaining severe damage during her fight with the German pocket battleship *Admiral Graf Spee* off the River Plate, Uruguay.

26th December, 1939

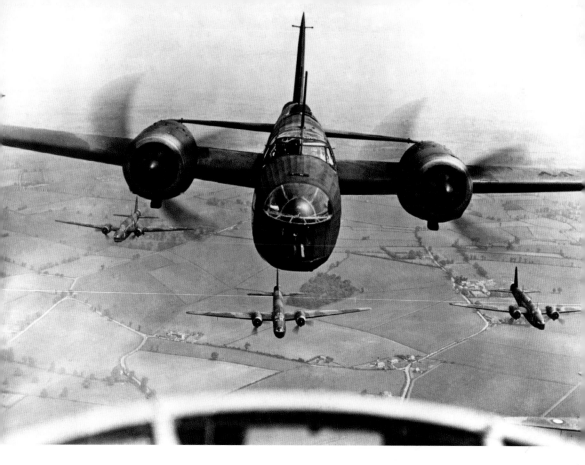

A squadron of RAF Vickers Wellington long-range medium bombers on exercise. The Wellington served as the mainstay of the RAF's bomber fleet during the early years of the war. It had an aluminium geodesic framework developed by 'bouncing bomb' designer Barnes Wallis that could absorb considerable damage without loss of structural integrity. As a result many crews returned safely when they might have been lost in other aircraft.
c.1939

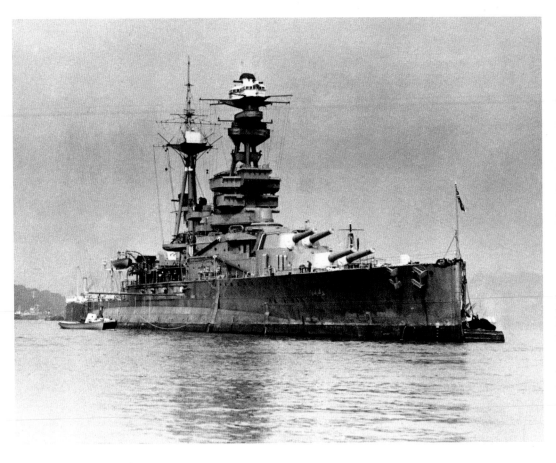

The battleship HMS *Royal Oak*, which was sunk by German submarine *U-47* while lying at anchor at Scapa Flow in the Orkneys on 14th October, 1939; 833 of her crew died.
c.1939

Right: British soldiers smile and wave from the deck of a troop ship as they sail to join the BEF in France.
c.1940

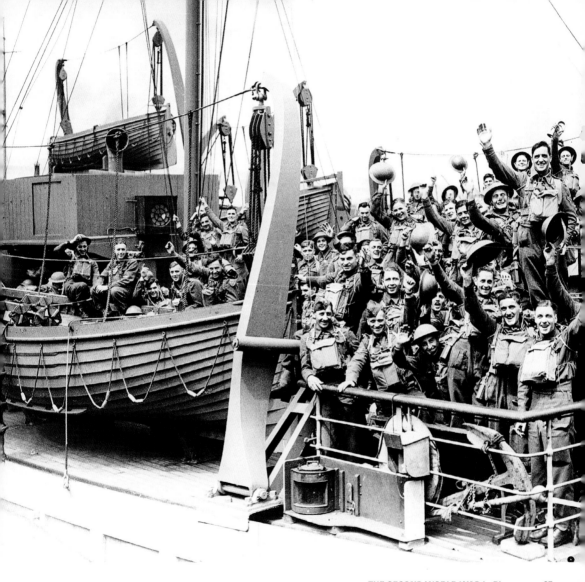

The "Gen." on Jane

Ack,

Jane and her pet dog Fritz appeared in a daily comic strip in the *Daily Mirror*, and during the war years, she was seen as a morale booster for the troops (Winston Churchill described Jane as Britain's secret weapon). Drawn by Norman Pett, Jane first appeared on 5th December, 1932 and continued until 10th October, 1959. Invariably, Jane's adventures led to her clothes being torn off, although until 1943 it was rare for her to appear completely nude, and it was all very innocent. Although Pett's wife, Mary, modelled for Jane at first, the strip's popularity increased when he began using Chrystabel Leighton-Porter, and she achieved celebrity status as a result.
c.1940

JANE
ON THE LAND

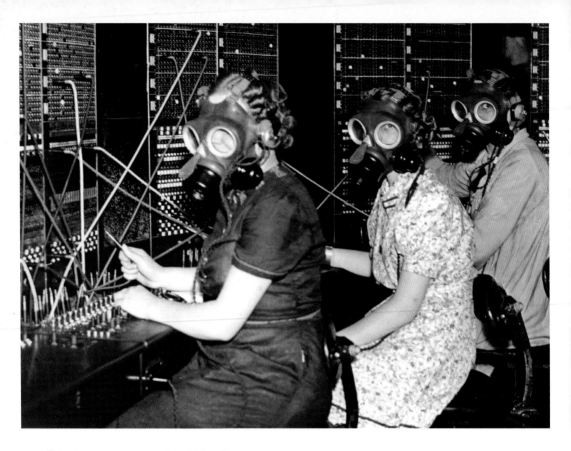

Telephone operators at Whitley Bay
telephone exchange practise working
in their specially adapted gas masks.
c.1940

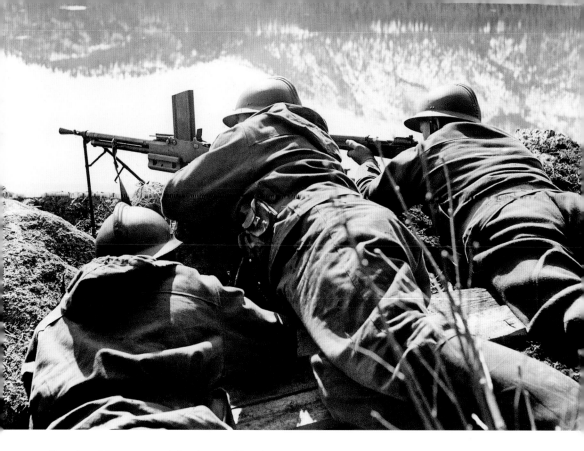

French soldiers man a defensive position in mountainous country in south-east France.
c.1940

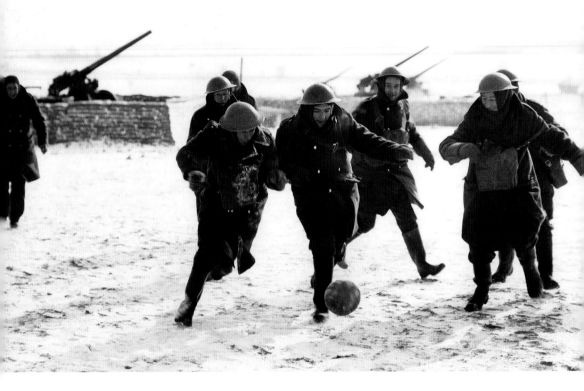

Members of a British anti-aircraft battery in France play football in the snow. The winter of 1939/40 was a quiet time for the troops of the BEF.

c.1940

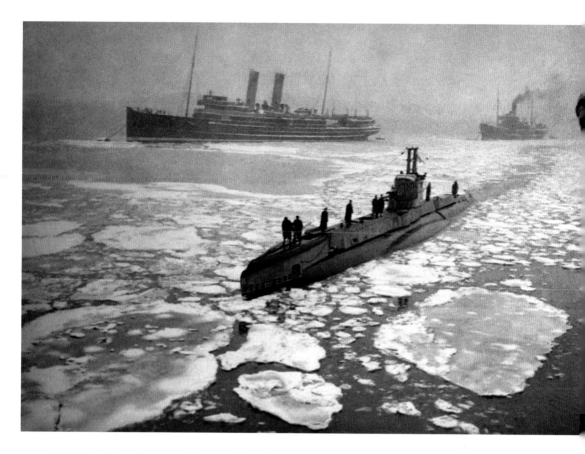

A British submarine noses its way through ice-covered waters at an east-coast port. In January, 1940, Britain experienced the coldest winter for 45 years, so cold that the sea froze in some places.

January, 1940

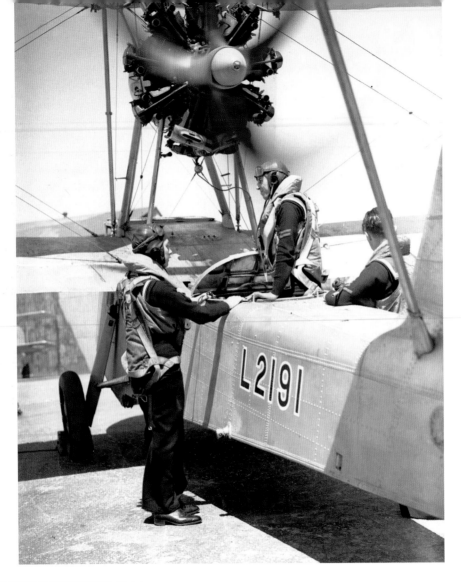

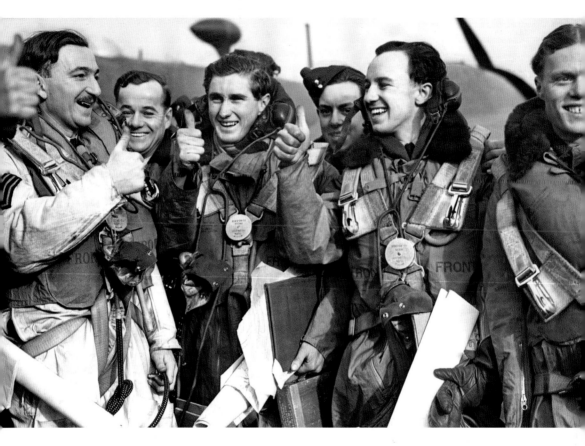

Left: The crew of a Supermarine Walrus climb aboard their aircraft at the Royal Naval Air Station, Lee on Solent, Hampshire. The Walrus was an amphibious biplane used for reconnaissance and air-sea rescue work.
c.1940

Thumbs up from the crew members of a Wellington bomber that had just returned from a successful mission.
January, 1940

At North Berwick, in Scotland, Squadron Leader Douglas Farquhar of the RAF's 602 Squadron damaged this German Heinkel III bomber, forcing it to make an emergency landing. Subsequently, the aircraft was repaired and used by the RAF to familiarise pilots with the enemy machine.

9th February, 1940

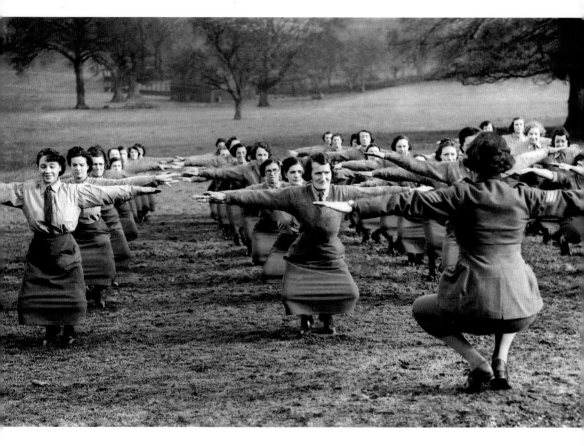

Auxiliary Territorial Service (ATS) recruits find that service skirts do not lend themselves to calisthenics at a camp attached to the Army's Western Command. The ATS was the women's branch of the Army and they carried out a number of non-combat support roles. As the war progressed and more fighting men were needed, they were employed as searchlight and anti-aircraft gun crews, while others became radar operators.
23rd February, 1940

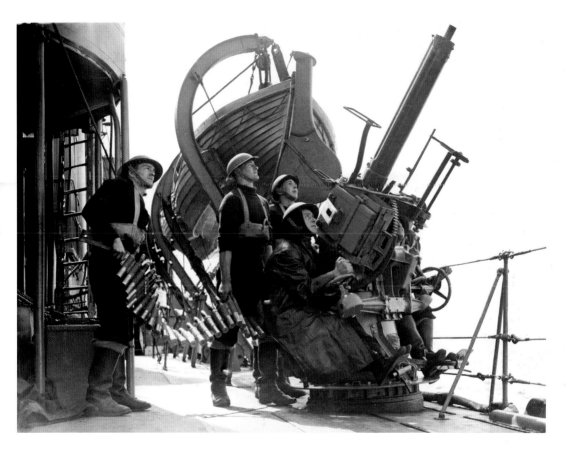

The crew of a 2-pounder 'pom-pom' gun, aboard a Royal Navy destroyer on escort duty, fire warning shots at an unidentified aircraft. The quick-firing cannon got its popular name from the sound it made when firing.

May, 1940

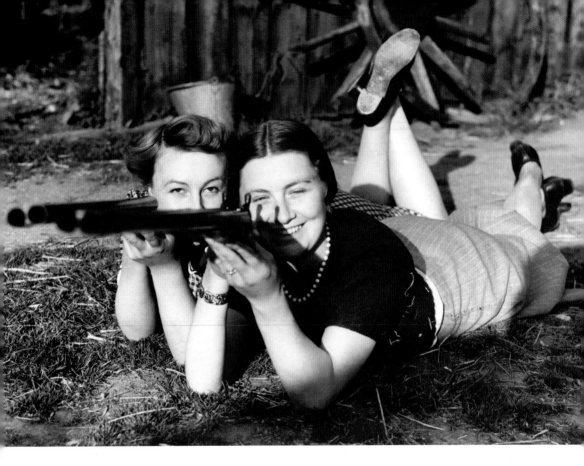

Two young women on a farm in Kent learn how to fire shotguns in case of invasion by German forces, which was a very real threat at the time.
24th May, 1940

Right: Crew members from the Belgian liner *Ville de Bruges* escape from the beached ship after it was bombed by the Germans as it left Antwerp. Four members of the crew were killed.
25th May, 1940

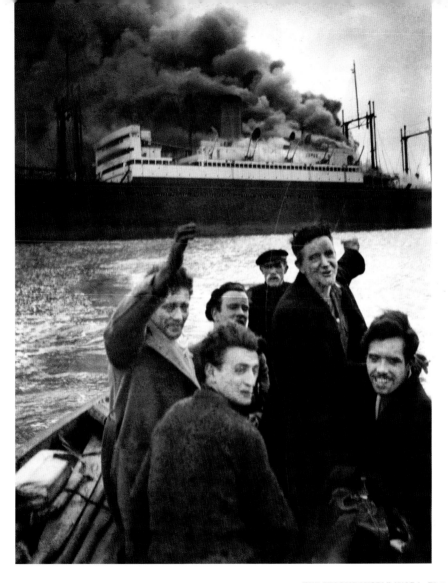

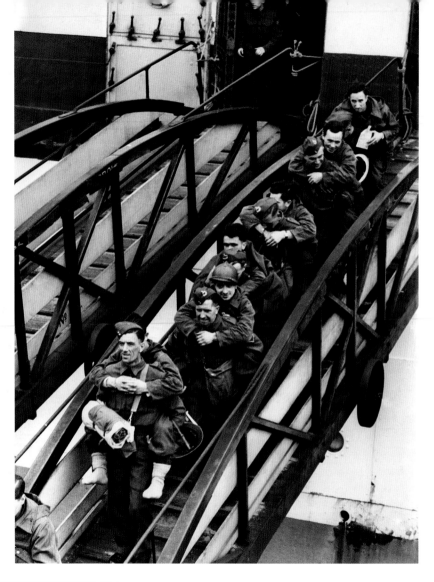

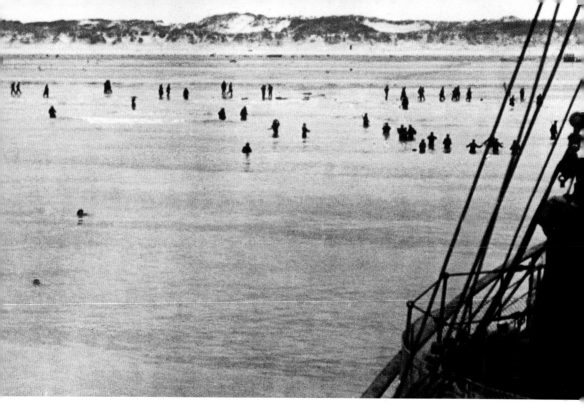

Left: Wounded French soldiers are carried ashore on the backs of British troops after being evacuated from France following the Germans' rapid advance. The ship had carried some 400 casualties to the English west-coast port.
28th May, 1940

British and Allied soldiers wade out to rescue vessels during the evacuation from Dunkirk in France. British, French and Belgian troops had been trapped in a pocket around the town by the Germans. A hastily assembled fleet of 850 vessels was sent to pick them up; between 27th May and 4th June, 338,226 were rescued.
June, 1940

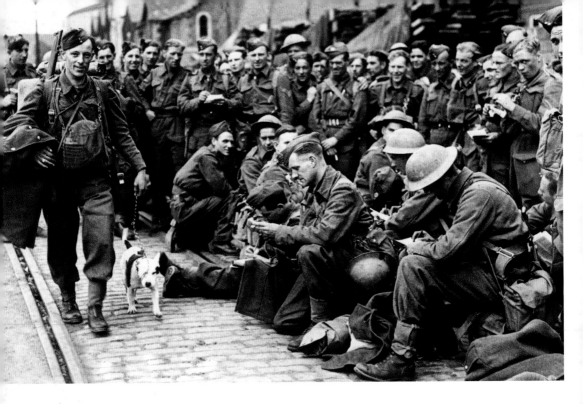

Following their evacuation from Northern France, British troops await orders and transport at a south-coast port. Clearly they have escaped in good order, since they retain their equipment; one even has a pet dog. Many men came back with only the clothes on their backs.

June 1940

Right: British troops cheer to return to a home port following their evactuation from Dunkirk. Many had to wait for hours shoulder-deep in water until they could be ferried out to large ships by small boats. Winston Churchill called their escape a "miracle of deliverance."

4th June, 1940

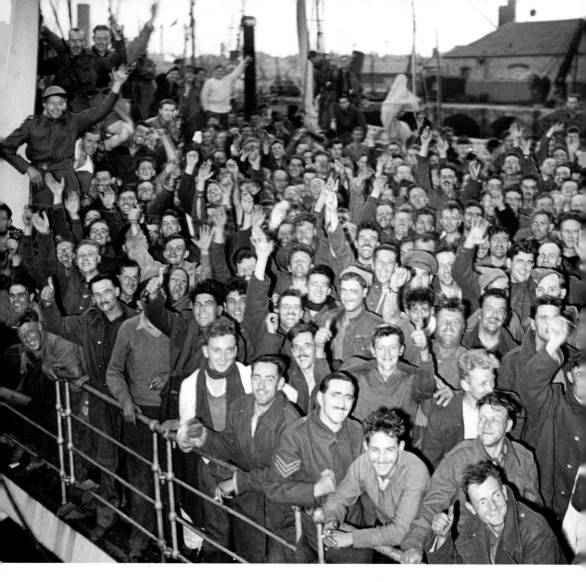

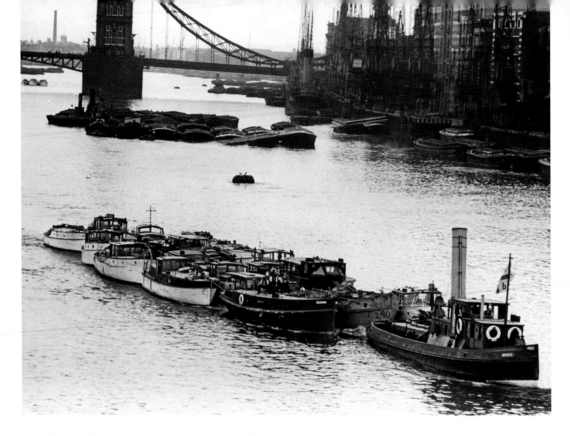

Small private boats, recently returned from Dunkirk, where they helped rescue the trapped Allied forces, pass through London on their way back to their owners. Some civilian crews participated in the evacuation by the 'little ships of Dunkirk', although most were manned by naval crews.
10th June, 1940

Right: A newsagent in Doncaster found this novel way to encourage his customers to recycle, or salvage, their old newspapers. A wide range of waste materials were recycled to aid the war effort in Britain.
20th June, 1940

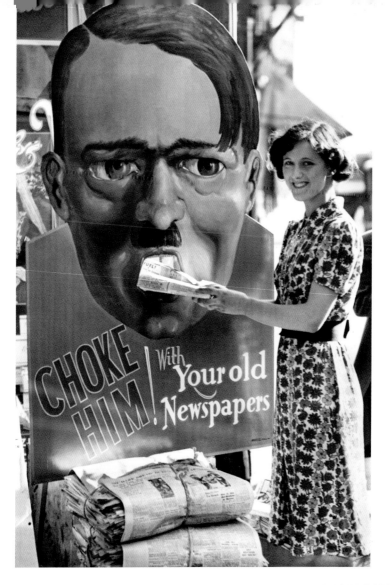

CHOKE HIM! With Your old Newspapers

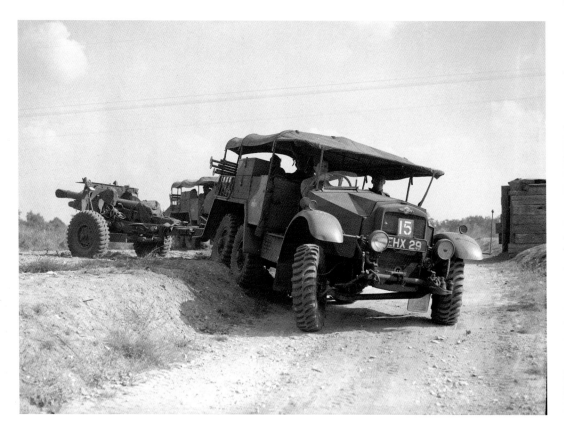

A British Army gun crew towing their 18-pounder field gun with a six-wheel Morris CDSW artillery tractor during a training exercise in England. For added traction, the truck's rear wheels could be wrapped in caterpiller-type tracks.

June, 1940

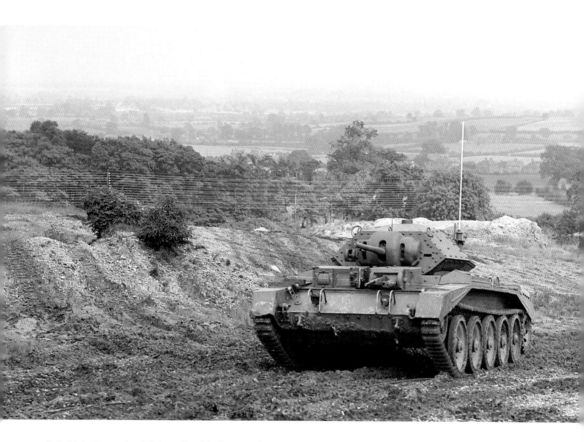

A British Crusader MkI tank with 2-pounder quick-firing cannon being tested near Salisbury plain in southern England. The Crusader was a fast tank and was used in large numbers during the North African desert campaign.

June, 1940

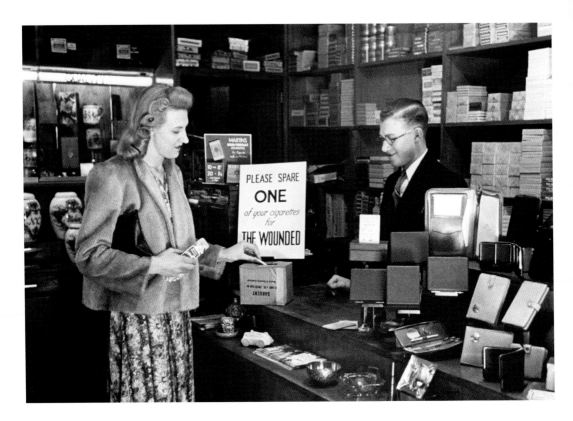

A woman buying cigarettes in a tobacconist's shop, in London, leaves one in a special collection box, which will be sent on to a hospital for wounded soldiers.
27th June, 1940

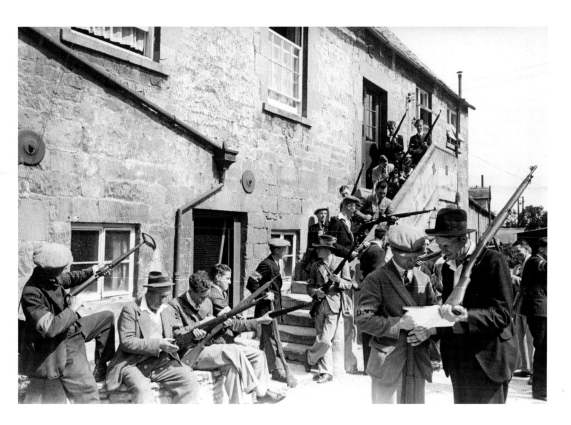

A unit of the newly-formed Local Defence Volunteers check their weapons during an exercise. Men between 17 and 65, not already in the forces, who wanted to help defend their country against German invasion, were urged to join the LDV, which became the Home Guard on 22nd July, 1940.

3rd July, 1940

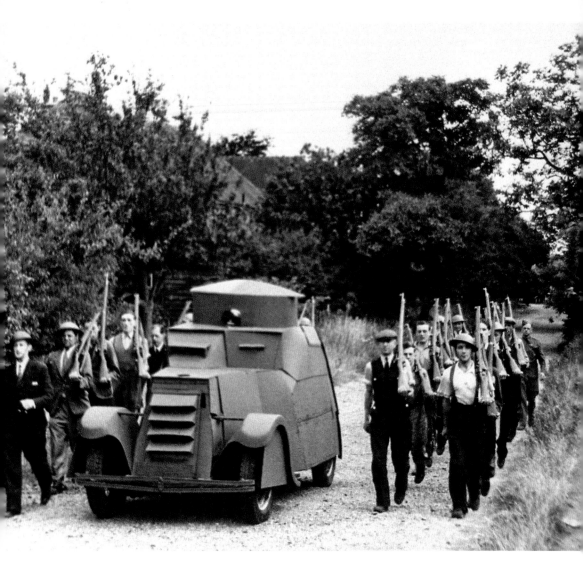

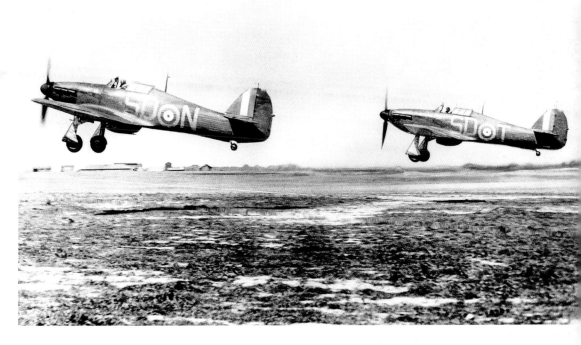

Left: An LDV unit, formed from workers at a jam factory, march beside their own armoured car during a lunchtime training session. Some have steel helmets, but they would have to wait a few months for uniforms. LDV arms varied considerably at first and were often improvised.

9th July, 1940

Hawker Hurricanes from 501 Squadron scramble to intercept a German raid from RAF Hawkinge, north of Folkstone on the Kent coast. Of the RAF's effort to combat the German assault, Winston Churchill said, "Never in the field of human conflict was so much owed by so many to so few."

20th July, 1940

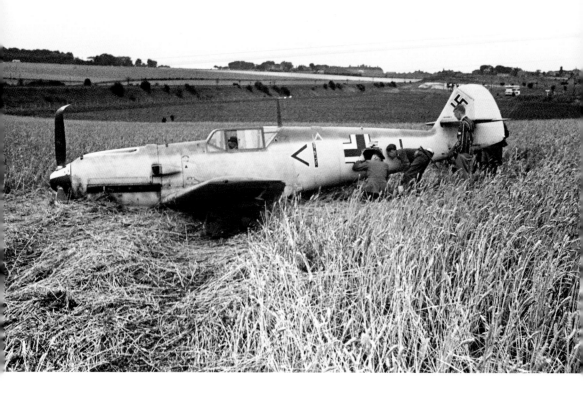

Members of an RAF technical team examine a downed Messerschmitt Bf109E fighter during the Battle of Britain. The machine packed a greater punch than the RAF's Spitfires and Hurricanes, being equipped with two 7.92mm machine guns firing through the propeller and two 20mm cannon in the wings.
30th July, 1940

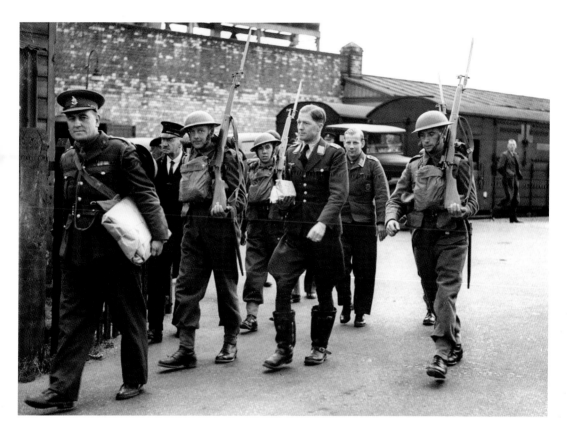

The crew from a downed German aircraft is taken into custody following an air-raid. The officer, who would have been the pilot, wears riding breeches with fur-lined flying boots, while his crewman is more conventionally dressed. Their lack of heavy flight suits suggests a low-level mission.

August, 1940

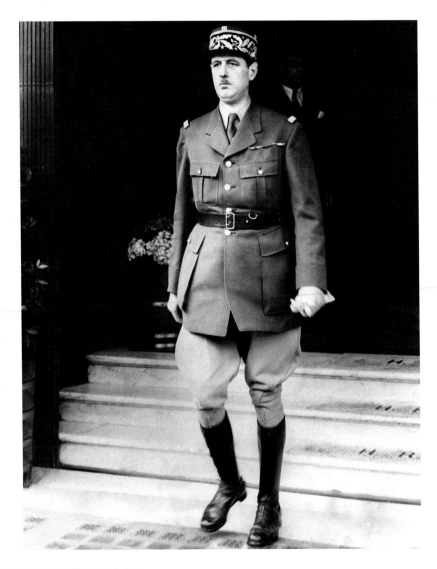

Left: General Charles de Gaulle, leader of the Free French forces. He had commanded an armoured division during the Battle of France and rejected the French surrender, as well as the collaboration with the Germans of the Vichy government. Despite being supported by the British and later Americans, he had a profound distrust of their motives and intentions towards France. He once said, "France has no friends, only interests."
3rd August, 1940

Right: A Royal Air Force fighter pilot catches up on some sleep between missions during the Battle of Britain, which lasted from 10th July to 31st October, 1940. At its height, RAF pilots in the south of England would be scrambled to meet incoming German raids several times a day.
18th August, 1940

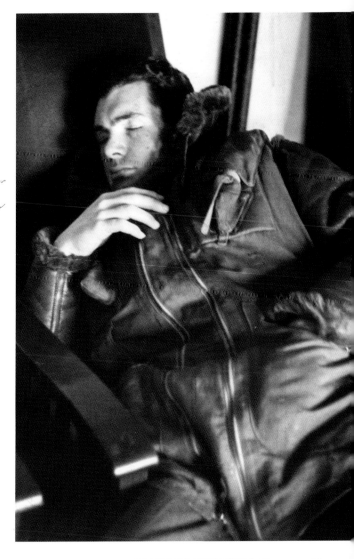

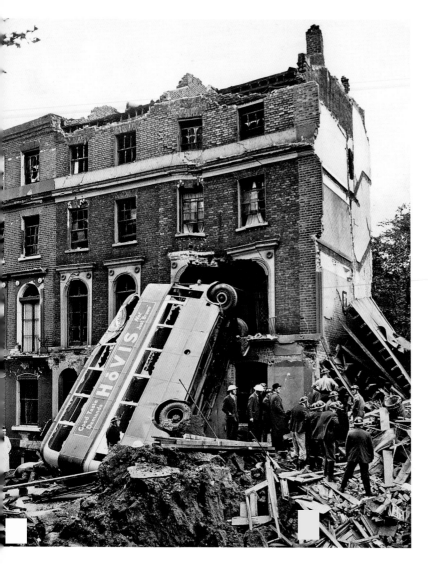

A double-decker London bus thrown like a toy against a building by the blast from a bomb dropped during an air raid. Fortunately, the crew and passengers had taken cover in a shelter when the raid began.

September, 1940

"Not on THIS Soil, Hermann!"

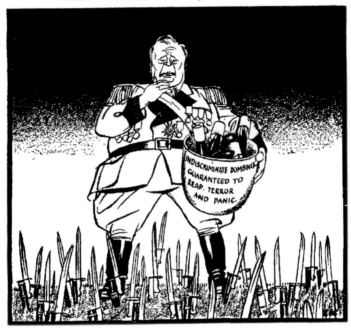

A Philip Zec cartoon from the *Daily Mirror*, showing a caricature of the head of the German Air Force, Hermann Goering, and implying that the British would not succumb to indiscriminate bombing. Having failed to destroy the RAF in the Battle of Britain, the Germans launched a massive bombing campaign, known as The Blitz, intended to bring about swift capitulation. Despite the ferocity of the onslaught, and the loss of life and ensuing damage, Britain remained resolutely defiant and refused to be cowed into surrender. Although bombing continued throughout the war, by May, 1941, The Blitz was over. Some 40,000 civilians had died, 46,000 had been injured and one million homes had been destroyed, but the Germans had lost 2,400 aircraft and achieved none of their objectives.
15th September, 1940

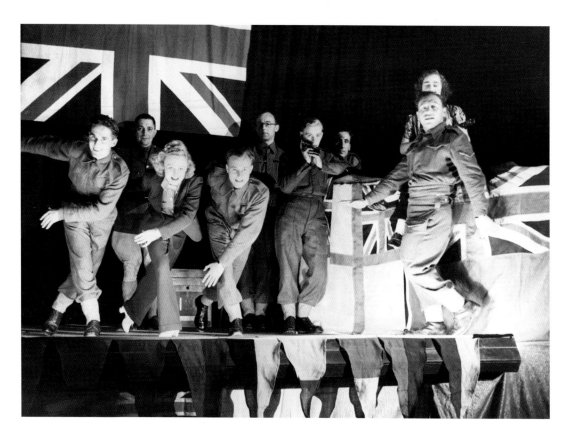

A group of professional actors serving in the Army, put on a show at a south-coast town to raise money for homeless Londoners.
14th October, 1940

Right: A *Daily Mirror* photographer was on hand to capture a dramatic image when Warden Mary Couchman bravely huddled over her son and two friends, protecting them against shrapnel with her own body, after they had been caught in the street during an air-raid.
17th October, 1940

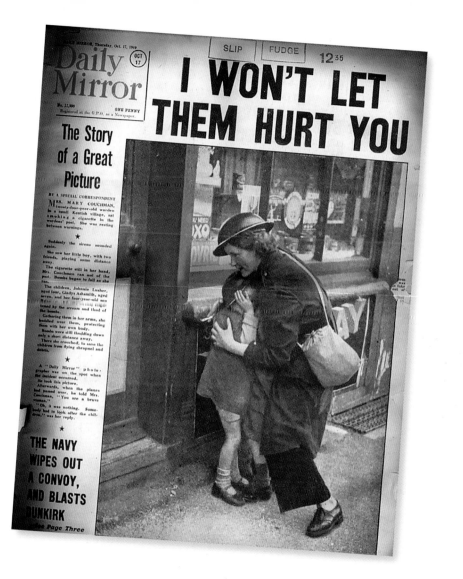

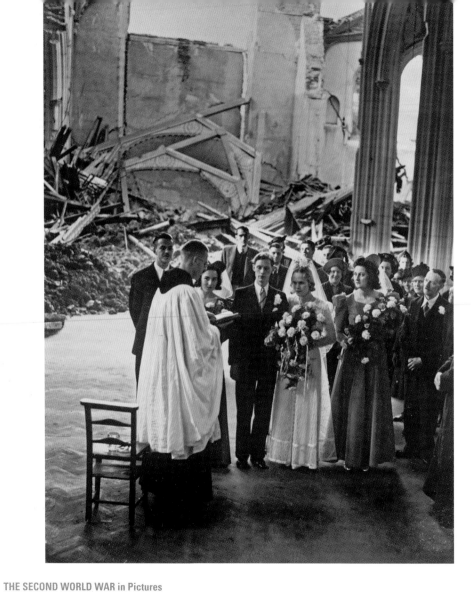

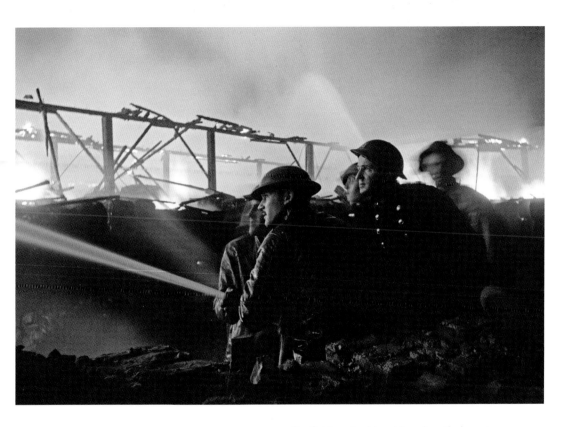

Left: Life goes on as normal in London during the Blitz. In the ruins of a bombed out church, a priest leads a wedding ceremony.
20th October, 1940

Firefighters tackle a blaze in a timber storage area after a raid on the London docks. In this instance, the photographer was arrested by the Port of London Authority, probably for security reasons, and his film confiscated.
25th October, 1940

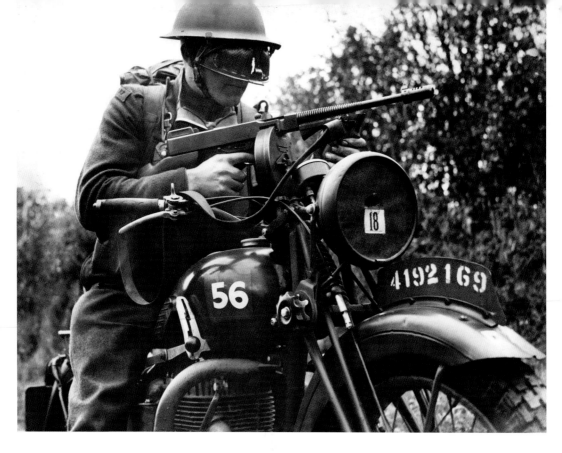

A British Army motorcyclist trains with a new weapon supplied from America, the Thompson submachine gun. Popularly known as the 'Tommy Gun', the weapon could be fitted with a 50-round drum magazine, as here, or a 20-round box. In use, it was found that the box magazine was far more efficient, so thousands of drums were returned to America for exchange with boxes.

3rd November, 1940

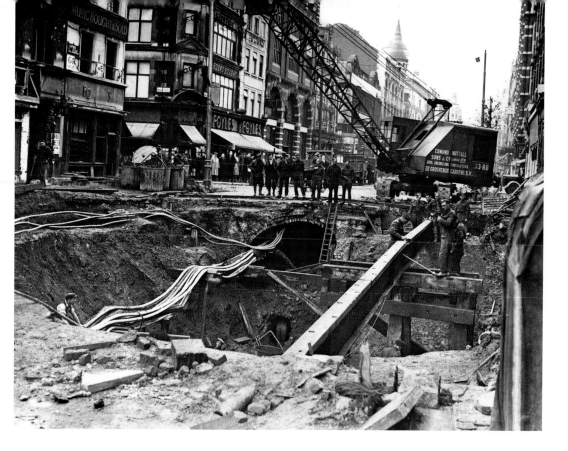

Work begins on repairing a huge bomb crater in Charing Cross Road, London, after an air raid.
11th November, 1940

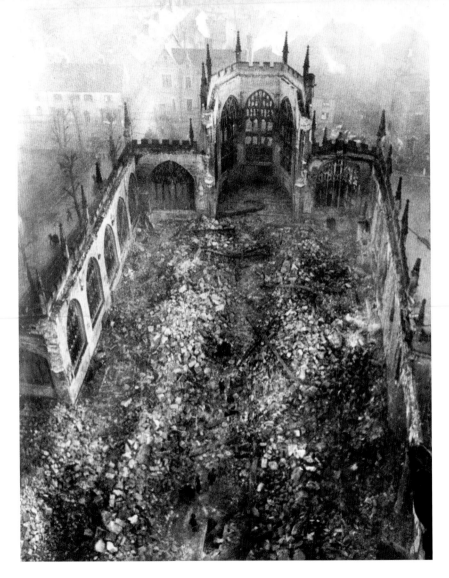

Left: An aerial view of the ruins of Coventry Cathedral after it had been destroyed by German bombers during a raid on 14th November, 1940. Over 500 aircraft took part in the raid, dropping 500 tonnes of high explosives and 36,000 incendiary bombs, which devastated the city
15th November, 1940

Oblivious to the firing of the guns, men from an anti-aircraft battery queue for their tea at a YMCA mobile canteen.
November, 1940

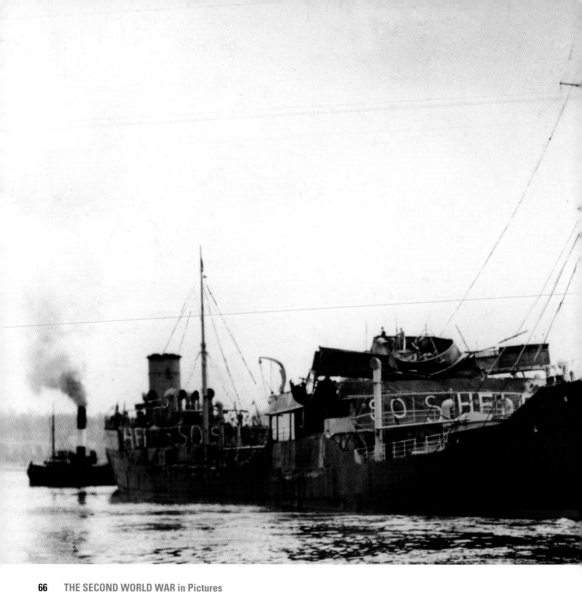

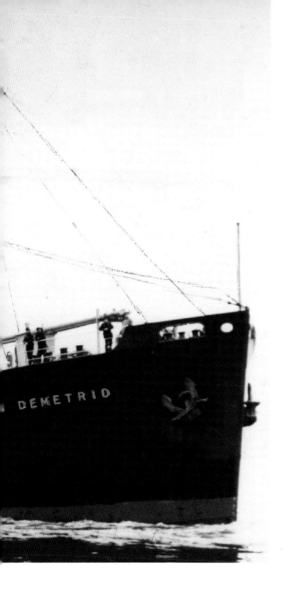

The badly damaged British tanker MV *San Demetrio* limps into the Clyde after a harrowing journey across the Atlantic. Loaded with aviation fuel, the ship had been part of a convoy heading for Britain that had been attacked by the German heavy cruiser *Admiral Scheer*. Several shells hit the tanker, destroying the bridge and setting the ship on fire. Fearful that the cargo would explode, the captain ordered the crew to take to the lifeboats. One, carrying the captain and 25 crew members, was picked up, but the other with the remaining 16 crew had drifted away. After enduring two nights in the open boat, the men could see their ship still afloat and still burning. They reboarded the vessel, put out the fire and then made sufficient repairs that they were able to get under way. Despite not having any navigational equipment or charts, they managed to sail the ship across the remainder of the ocean, braving bad weather and German submarines. The story was made into a film, *San Demetrio London*, in 1943, one of the few wartime films to recognise the bravery of merchant seamen.
16th November, 1940

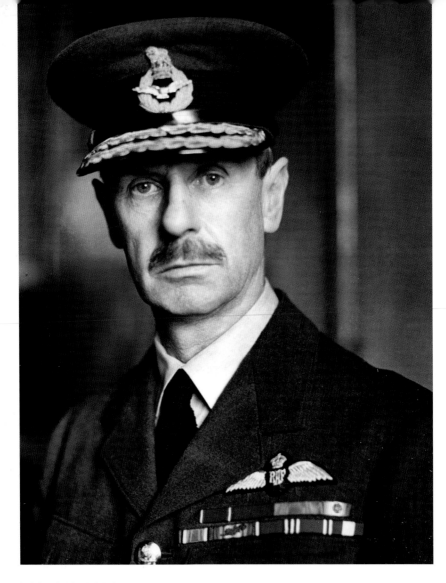

Left: Air Chief Marshal Sir Hugh Dowding, commander of the RAF's Fighter Command during the Battle of Britain. His careful preparation of Britain's air defences and prudent use of his command's resources were largely responsible for victory in the battle.

17th November, 1940

Right: As part of the war on waste, people were encouraged to recycle bones, which could be made into glue. One generous canine has a last nibble before his bone goes in the bin.

22nd November, 1940

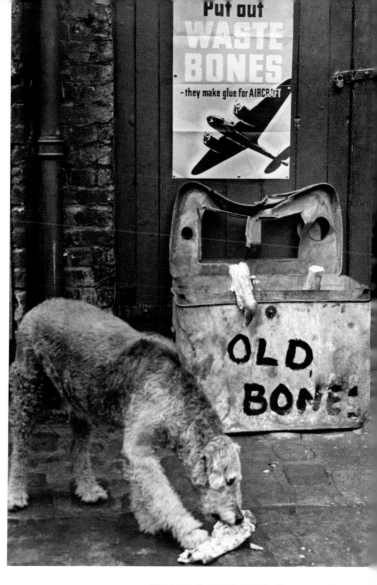

Flight Lieutenant James Nicolson (third R), of 249 Squadron, who was the first fighter pilot of the war to be awarded the Victoria Cross. On 16th August, 1940, he was injured in one eye and a foot during a dogfight with a German Messerschmitt fighter, and his Hurricane was set on fire. As he was baling out, he spotted another Messerschmitt, so struggled back into his blazing aircraft and attacked it, continuing to fire until it dived away to crash. As he descended by parachute, he was fired upon by a Home Guard patrol who thought he was German.
November, 1940

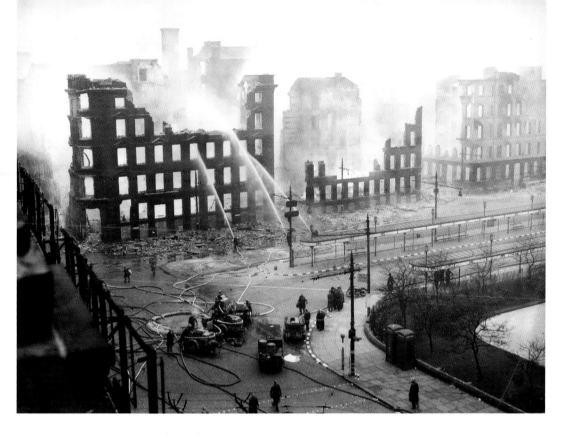

Firefighters play water from their hoses on the smouldering remains of offices in the centre of Manchester following a bombing raid by the German Air Force. Two raids on the city in December, 1940 killed more than 680 people; around 2,364 were injured.

December, 1940

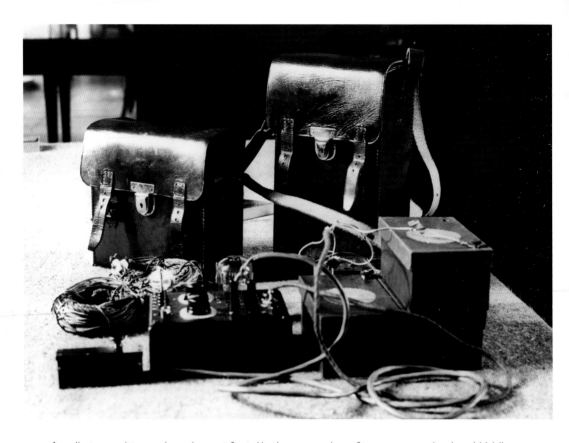

A radio transmitter and receiver set found in the possession of two enemy spies, Jose Waldberg, a 25-year-old German, and Karl Meier, a 24-year-old German-born Dutch national. Both men had carried papers showing them to be Dutch refugees. Convicted of treason, they were executed at Pentonville Prison in London, in December, 1940.
10th December, 1940

Right: A seaman climbs a ship's mast to adjust the huge kite that carries a slender cable to make an effective barrage against enemy aircraft, forcing them to fly higher and making aerial attacks more difficult. Each ship in a convoy would be equipped with one of these.

21st December, 1940

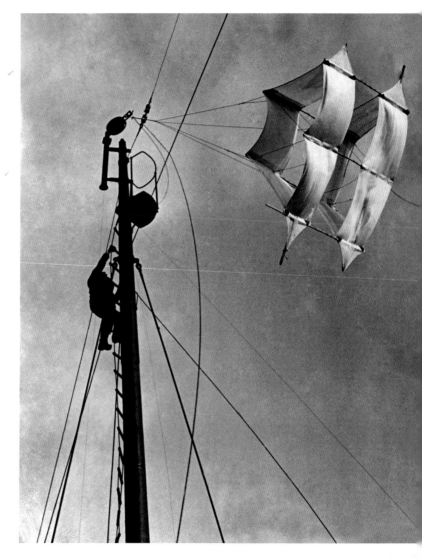

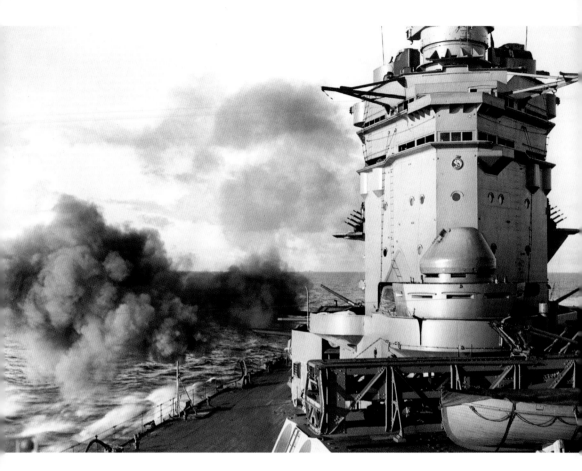

The Royal Navy's battleship HMS *Rodney* fires her secondary armament of six-inch guns during exercises at sea. One of only two ships in the Navy with a main armament of 16-inch guns, the *Rodney* played a major role in the sinking of the German battleship *Bismarck* in May, 1941, as well as the Allied landings in North Africa and Normandy.

23rd December, 1940

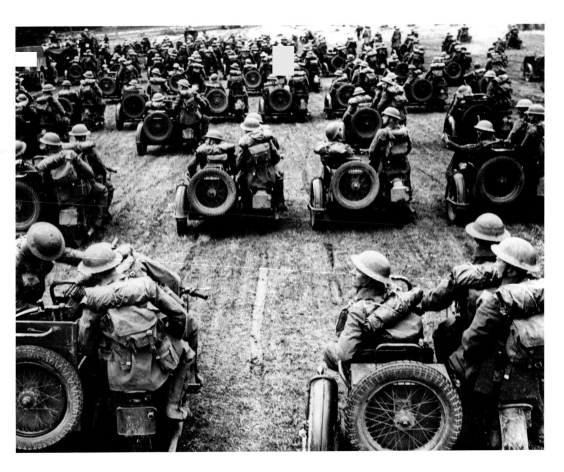

The 8th Battalion Royal Northumberland Fusiliers, a motorcycle unit tasked with reconnaissance. Each motorcycle sidecar was fitted with a light machine gun. Later in the war, such units would be equipped with armoured cars.

27th December, 1940

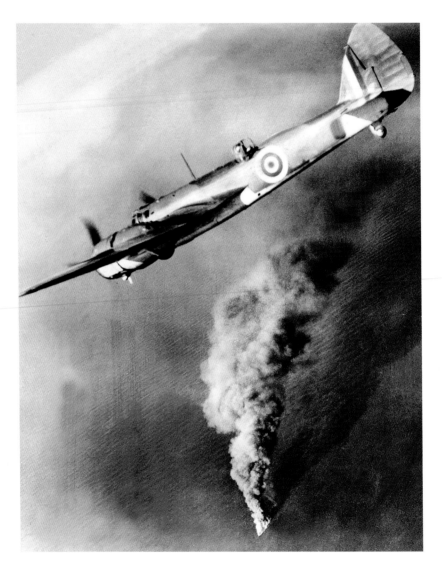

Left: A Royal Air Force Bristol Blenheim light bomber flies over the burning hulk of a German tanker. Introduced in 1937, the Blenheim was faster than the biplane fighters of the day, but by 1940, it had been outclassed by the German Messerschmitts and often suffered heavy casualties. However, a night fighter version proved very effective.
c.1940

Right: Heinrich Himmler, chief of the German paramilitary Schutzstaffel (SS) and the head of the secret police (Gestapo). One of the most powerful men in Germany, he was primarily responsible for the Holocaust and many other atrocities committed by the Nazi regime. At the end of the war, after being caught by British troops, he committed suicide.
c.1940

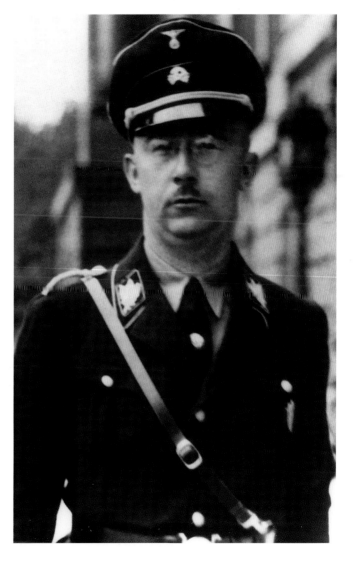

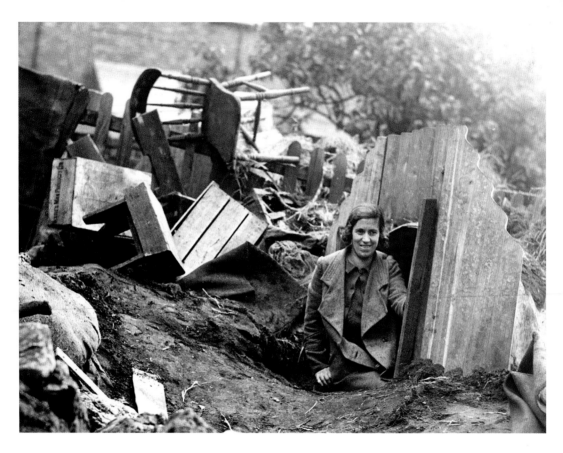

A young woman emerges from an Anderson shelter after a heavy night of bombing. Built from corrugated iron, the Anderson shelter was distributed free to households earning less than £250 a year, and cost £7 for those with a greater income. They were erected in a pit and covered with more soil, and were very effective. In all, 3.6 million were issued. After the war, many people retained their Anderson shelters, converting them to garden sheds.
c.1940

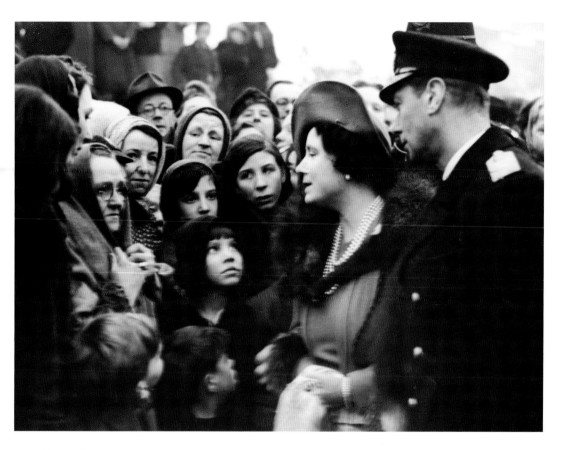

Queen Elizabeth and King George VI talk to
a group of people made homeless in one of
the most heavily raided areas of Sheffield.
6th January, 1941

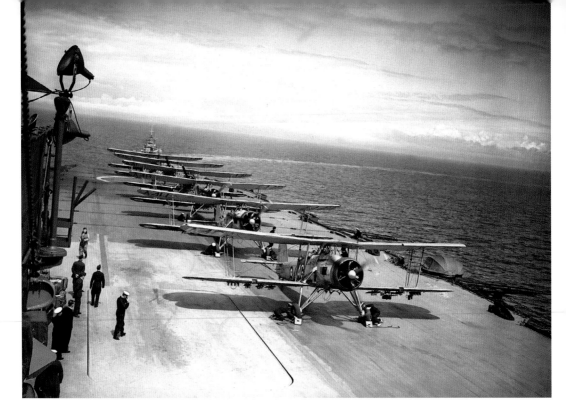

Fairey Swordfish torpedo bombers prepare to take off from the aircraft carrrier HMS *Ark Royal*. Outdated and slow, nevertheless these biplanes achieved some notable successes during the war, including the disabling of the German battleship *Bismarck* on 26th May, 1940. The *Ark Royal* took part in a number of important actions, including the hunt for the German battleship *Admiral Graf Spee*, operations off Norway, the hunt for the *Bismarck* and the Malta convoys. After surviving a number of near-misses, she was torpedoed on 13th November, 1941 by the German submarine *U-81* off Gibraltar, sinking the following day, remarkably with the loss of only one life.

c.1941

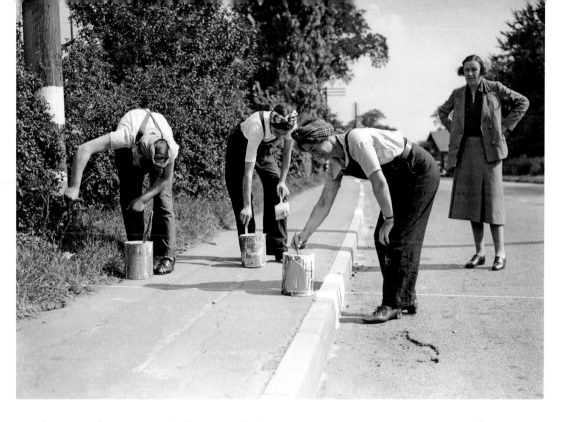

A group of women road painters mark the kerb and other roadside obstructions with white paint so that they will be more visible during the blackout.
1941

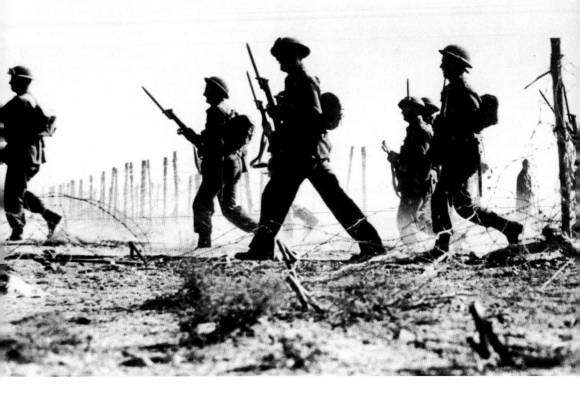

British infantry pass through a gap in the barbed wire defences during the advance on the Libyan port of Tobruk, occupied by Italian forces. It fell two days later and became an important site of battles between Allied and Axis forces during the Western Desert Campaign.
20th January, 1941

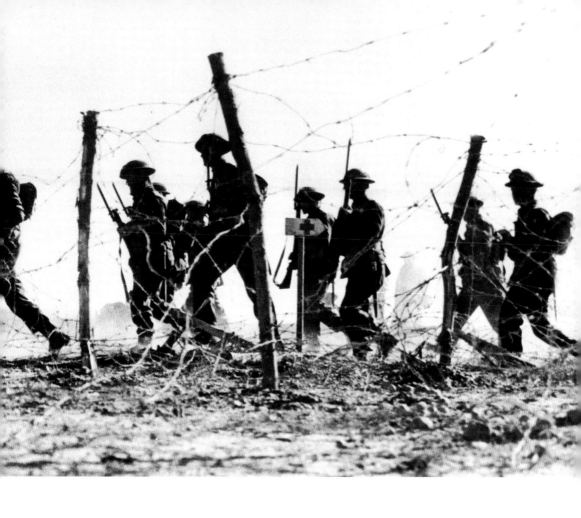

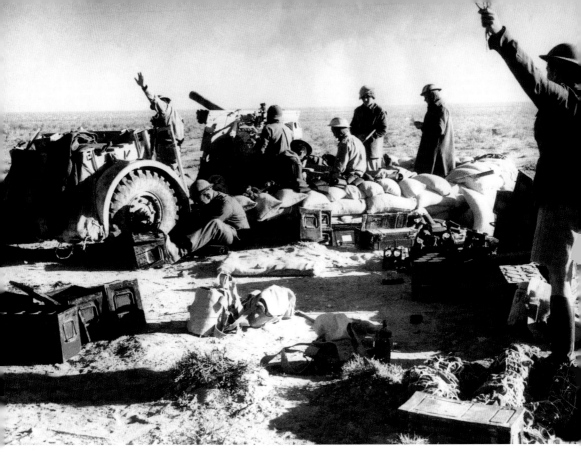

A British 25-pounder gun fires on Tobruk
just before the troops entered the town.
January, 1941

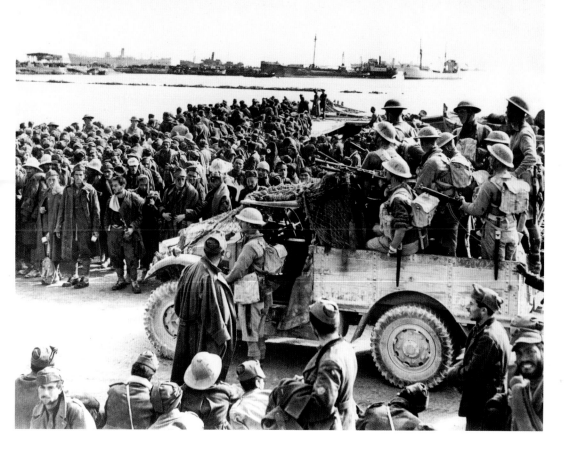

Prisoners, captured during the British Army's operation to oust Italian troops from western Egypt and eastern Libya, wait at Sollum to be shipped to PoW camps. The British action was a major success: they took 115,000 prisoners, and destroyed thousands of tanks, artillery pieces and aircraft. The Italian defeat prompted Adolf Hitler to intervene by sending German forces to North Africa; with their arrival, the campaign took a completely different turn.
5th February, 1941

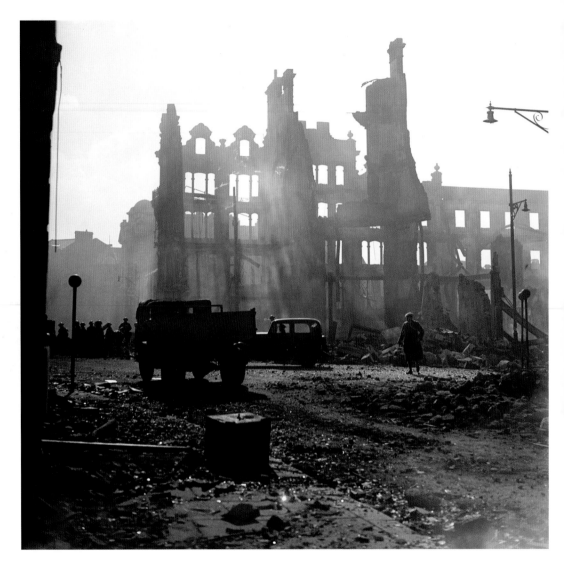

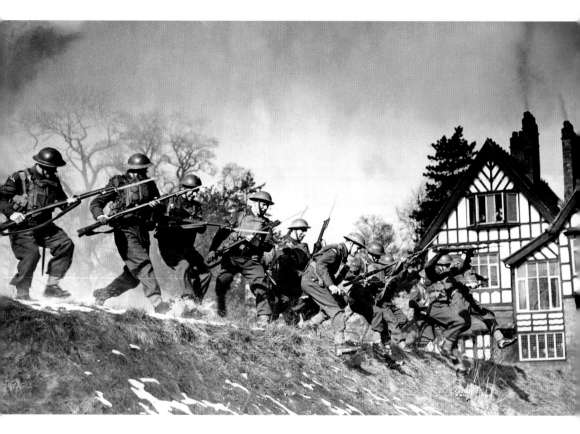

Left: Dawn breaks over Swansea after the city had endured a three-night blitz. The heavy and sustained attack by the German Air Force was part of their strategic campaign aimed at crippling coal exports as well as demoralising the civilian population.
22nd February, 1941

Parachute troops in training at a battle school somewhere in England.
27th February, 1941

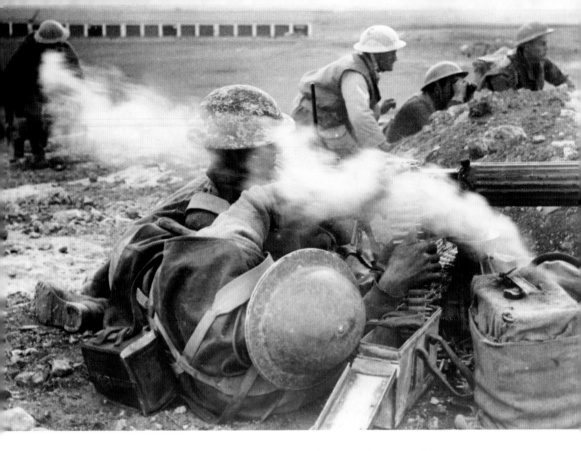

Men of a British machine gun battalion exchange fire with elements of the German Afrika Korps on the outskirts of Derna in Libya. They are using a Vickers heavy machine gun, which had a water jacket around the barrel to cool it. The heated water would expand and be collected in a can, which can be seen in the foreground discharging a plume of steam. The man lying down is feeding a new belt of ammunition into the weapon.
27th February, 1941

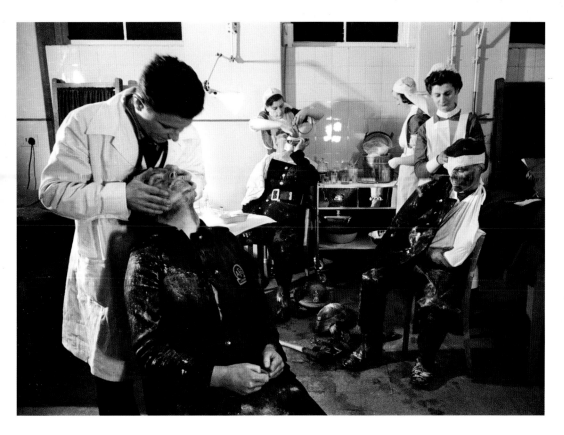

Injured firefighters receive treatment at Westminster Hospital after another night of The Blitz. The London Fire Service and Auxiliary Fire Service had a strength of 20,000 men and women during the war.
1st March, 1941

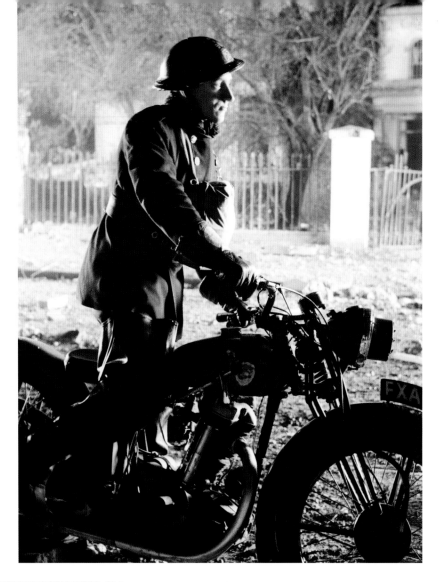

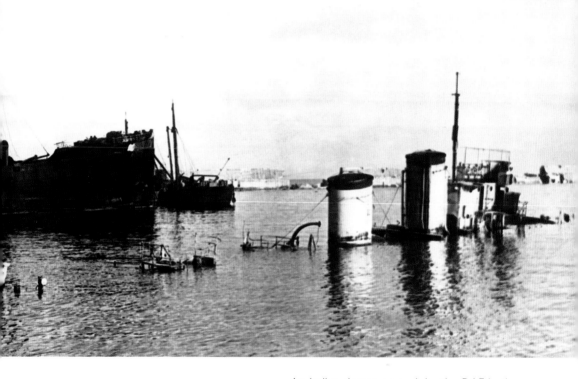

An Italian destroyer sunk by the RAF in the Libyan port of Benghazi.
9th March, 1941

Left: A fire service dispatch rider in Streatham, South London, during The Blitz.
8th March, 1941

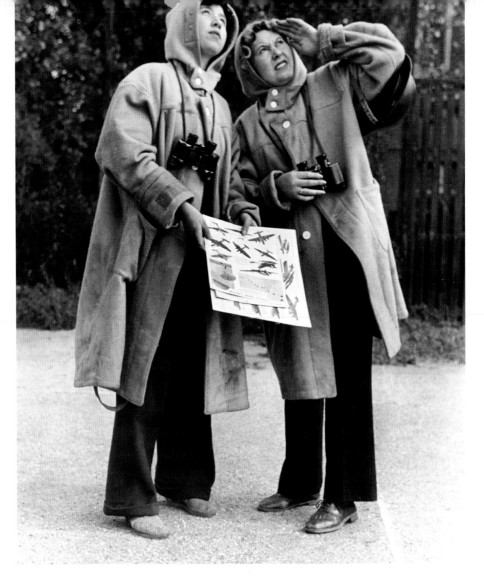

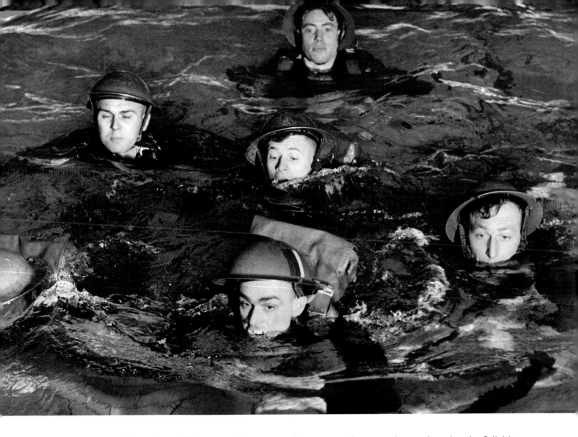

Left: Members of the Royal Observer Corps practise aircraft recognition. The network of ROC posts was the only means of tracking enemy aircraft once they had crossed the coast and passed through the radar chain. Women were admitted to the corps for the first time in 1941.
1941

Army recruits practise swimming in full kit, including their steel helmets.
30th March, 1941

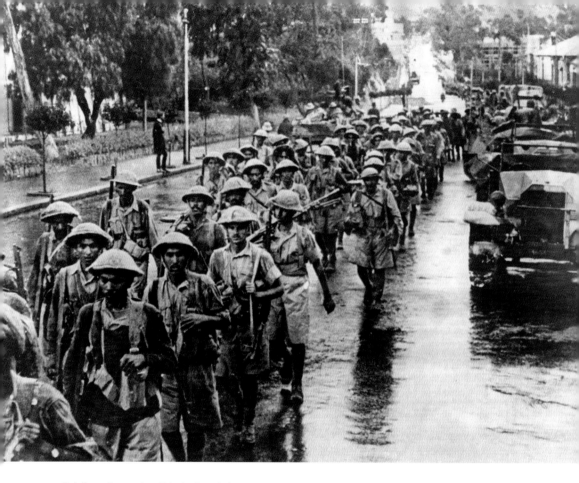

Soldiers from the 5th Indian Infantry Brigade enter Asmara, capital of Eritrea, during the East African Campaign fought by British Empire and Allied troops against the forces of Italian dictator Benito Mussolini, who had sought to create an Italian East African Empire. The campaign ran from June, 1940 until November, 1941, when the Italians finally surrendered.
1st April, 1941

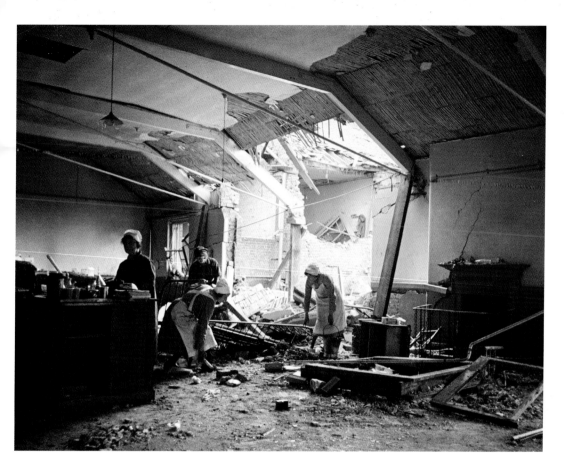

Nurses help clear up bomb damage and
salvage whatever they can find at a London
hospital. The German bombing of the city
was indiscriminate.
9th April, 1941

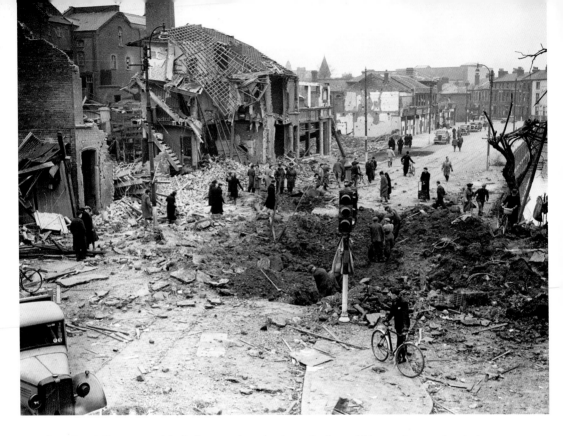

People of Coventry pick their way gingerly through the rubble as they make their way to work following a German air raid on the previous night. The city had been attacked by 230 bombers, which dropped 315 tonnes of high explosive and 25,000 incendiaries. They would return that night and the following night, killing around 450 people and injuring over 700.
9th April, 1941

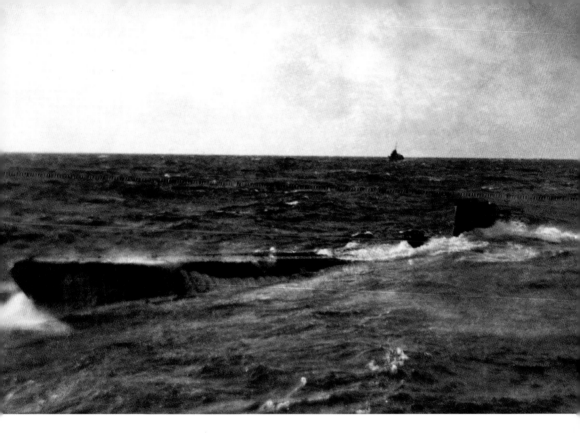

A German submarine is forced to the surface following an attack by Royal Navy destroyers and corvettes escorting a convoy across the North Atlantic. Germany had the largest submarine fleet of the Second World War and employed the 'wolf pack' tactic, whereby a large number of boats would be strung out in a line in mid-Atlantic waiting for convoys. As soon as one was sighted, they would all home in on it, overwhelming the escorts.

28th April, 1941

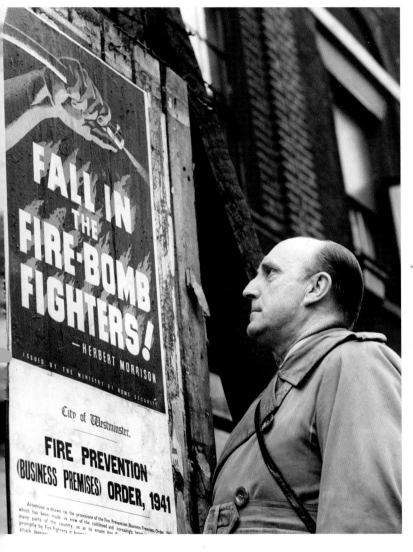

The use of incendiary bombs was common on both sides during the war. They would often be dropped with high-explosive bombs to set fire to buildings once they had been blown apart. Because of the problem caused by incendiaries a campaign was launched to encourage men to sign up as fire watchers to combat the menace during their spare time. They would be issued with a steel helmet, an armband and a stirrup pump to put out the burning devices.

4th May, 1941

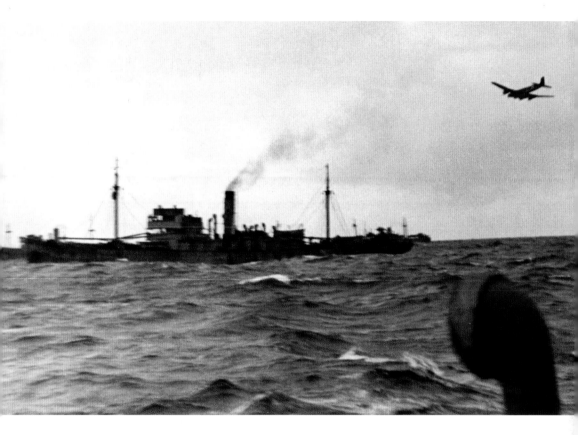

A German four-engine Focke-Wulf Condor sweeps out of the clouds to attack a convoy in mid-Atlantic. All the bombs fell harmlessly into the sea. The Condor was a development of a civilian airliner and was the only truly long-range aircraft the Germans possessed. Its threat was soon countered by long-range Allied aircraft, escort carriers and ship-borne, catapult-launched fighters. It then reverted purely to a reconnaissance role.

5th May, 1941

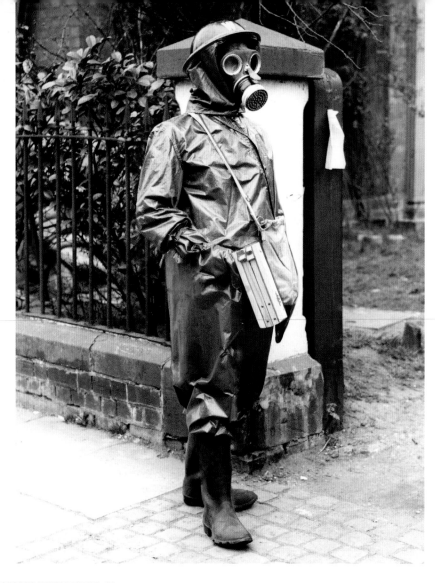

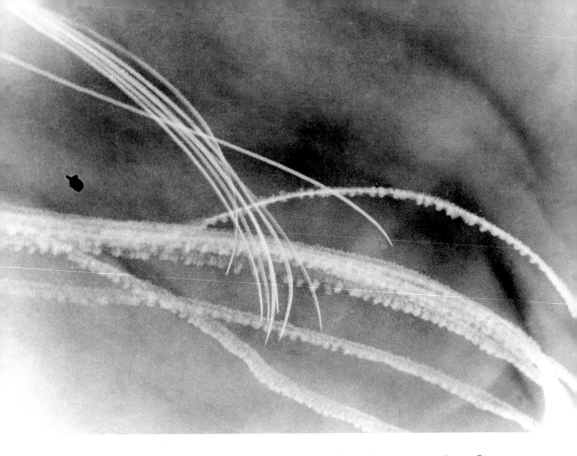

Left: A Coventry ARP warden in full anti-gas protective clothing. The rattle was to warn people of a gas attack.
6th May, 1941

The sky fills with vapour trails as German aircraft are engaged by RAF fighters following a hit-and-run raid on London. A solitary barrage balloon can be seen at left.
8th May, 1941

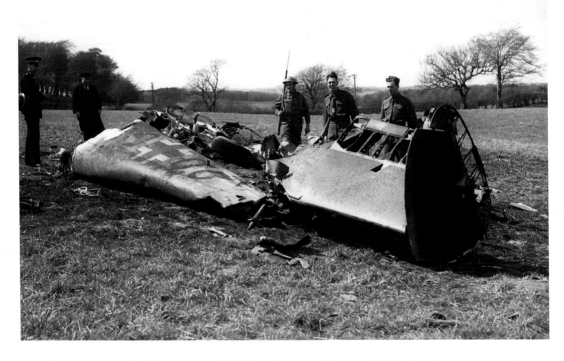

The wreckage of a Messerschmitt ME110 twin-engine fighter, which had crashed to the south of Glasgow in Scotland. The aircraft had been piloted by Rudolf Hess, Adolf Hitler's deputy in the German Nazi party, who had parachuted from the aircraft before it had crashed. Hess had flown to Britain on a personal mission to negotiate peace, but instead he was imprisoned. After the war, he was sentenced to life imprisonment at Nuremberg and was sent to Spandau prison, Berlin, where he commited suicied in 1987 at the age of 93.
11th May, 1941

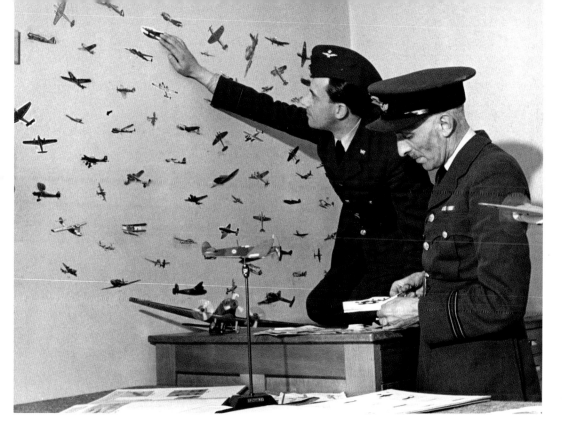

An RAF officer cuts pictures of enemy
aircraft from magazines to stick on the walls
of his classroom to improve the aircraft
recognition skills of his pupils.
11th May, 1941

Right: Robert Alexander Watson-Watt, who oversaw the development of radar during the late 1930s. His work led to the construction of a series of radar stations along Britain's south and east coasts, which provided vital aircraft location information during the Battle of Britain.
June 1941

Far right: Winston Churchill takes aim with an automatic. Having seen active service on the Northwest Frontier of India in 1897, the Prime Minister was anxious to demonstrate that he knew the business end of a rifle.
19th June, 1941

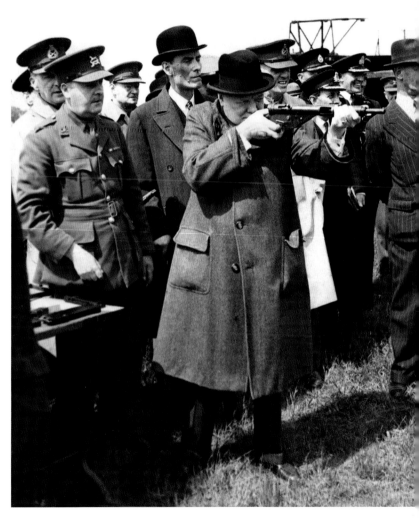

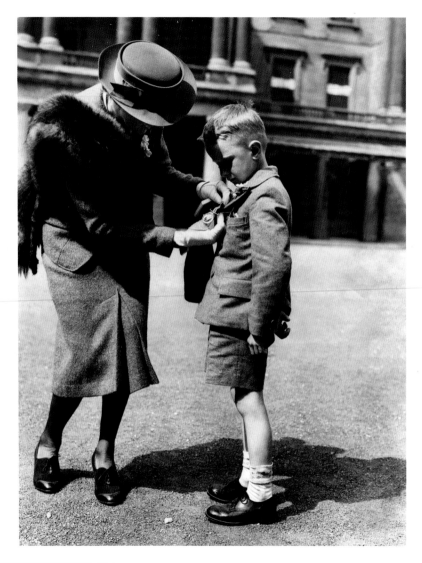

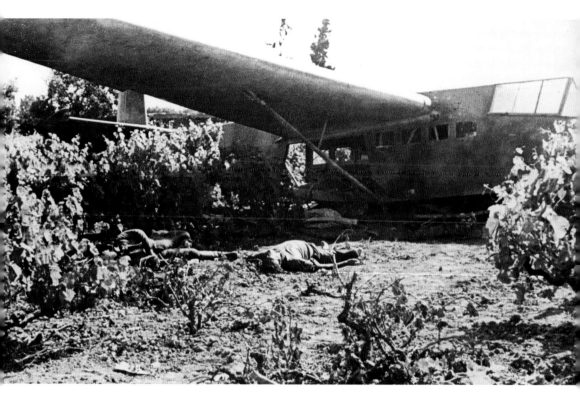

Left: After an award ceremony held at Buckingham Palace, the widow of naval officer John Buchanan (who died on HMS *Triad* when the submarine was torpedoed in the Mediterranean) pins the Distinguished Service Medal (DSM) with which she has just been presented by King George VI onto the lapel of her son David.
24th June, 1941

The bodies of two German airmen lie beside their glider which crashed in Crete during the savage battle for the island at the end of May.
26th June, 1941

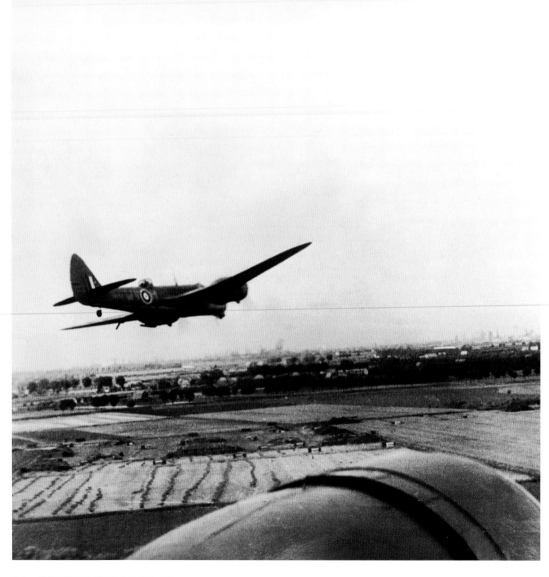

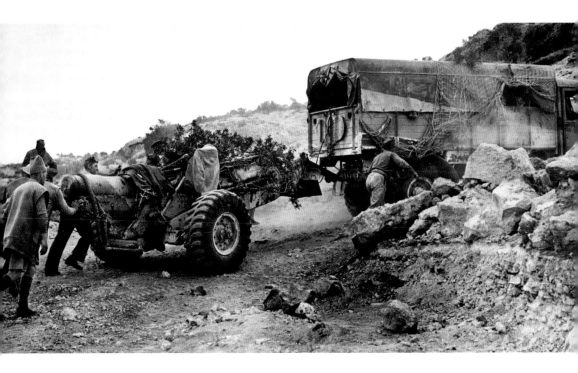

Allied troops struggle with a medium field gun and limber on the escarpment near Giovanni Berta in the Libyan desert, on their way to join the forward troops.
28th July, 1941

Left: RAF Blenheims swoop low in 'V' formation over the Dutch countryside as they approach their target – shipping in the port of Rotterdam.
16th July, 1941

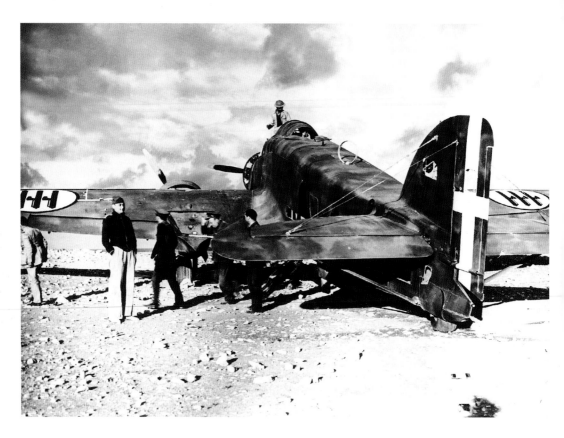

British troops examine the wreckage of an Italian S79, which landed on the edge of the Sidi Barrani Aerodrome in Egypt's Western Desert after being attacked by Allied fighter aircraft. Three of the crew died and the others were captured.

1941

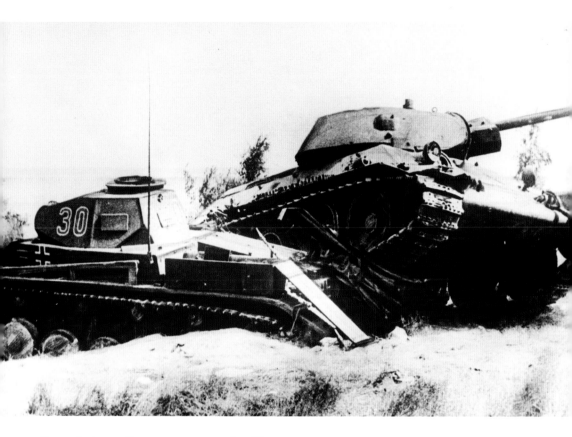

One of three German panzer tanks (L) crushed by Captain Kukushkin's Soviet tank during fighting on the Eastern Front after the Nazis launched Operation Barbarossa and invaded Russia in June 1941.

August, 1941

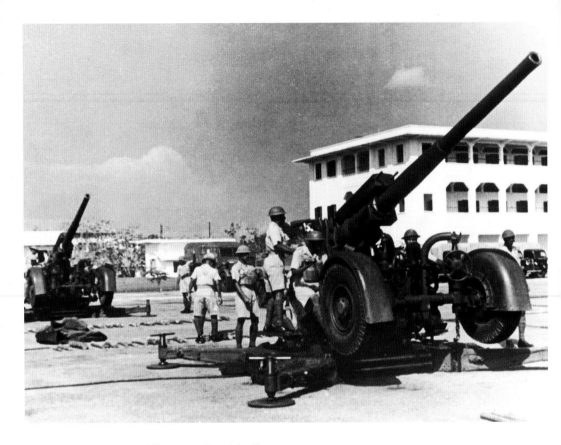

The Hong Kong and Singapore Royal Artillery (HKSRA) operating an anti-aircraft gun used in the defence of Malaya when the Southeast Asian country was invaded by Japan.
3rd August, 1941

Right: Troops of the Australian Imperial Forces (AIF) step carefully through jungle while training for the defence of Malaya.
13th August, 1941

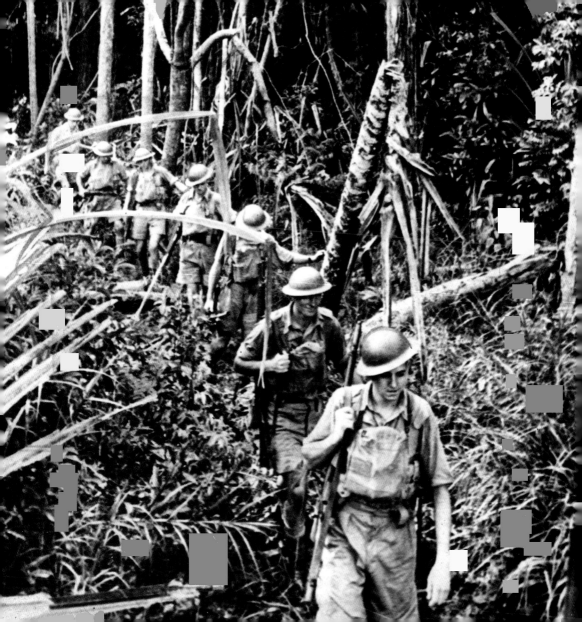

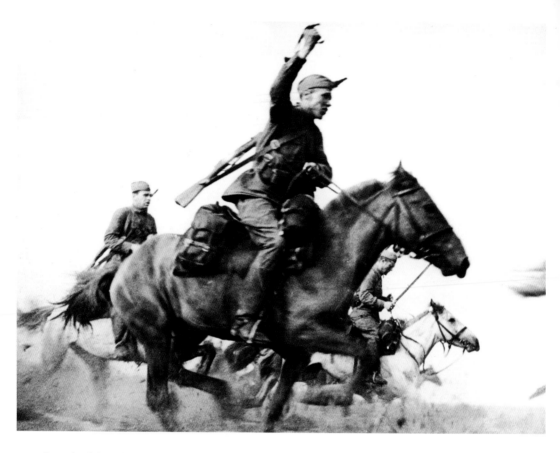

Surprised by the Barbarossa invasion, the Soviets resisted the Nazi invaders with every means at their disposal. Here mounted troops of the Red Army launch a counter-attack against the Germans.
September 1941

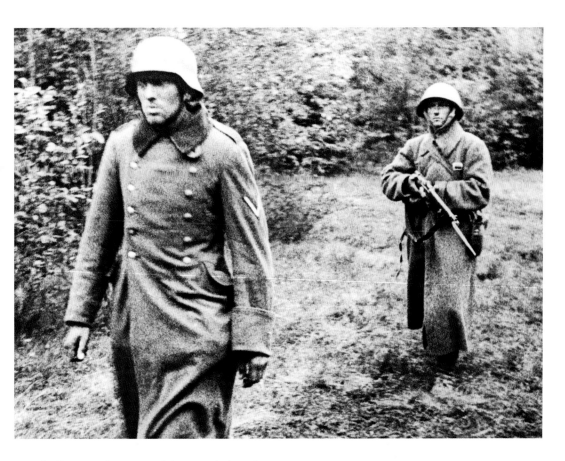

A German Army scout is escorted under armed guard by a Red Army soldier after being captured on the Eastern front.

12th September, 1941

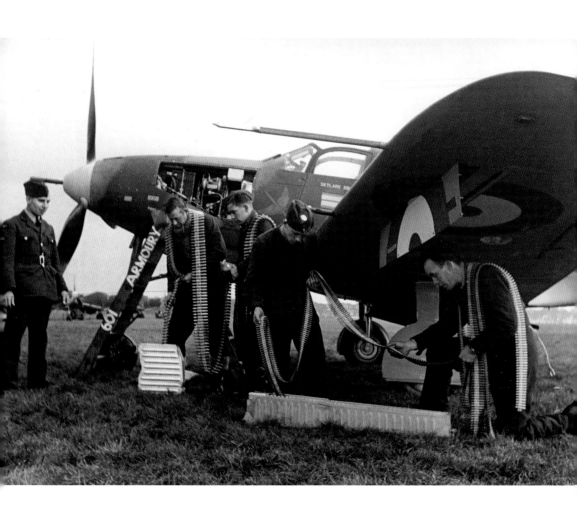

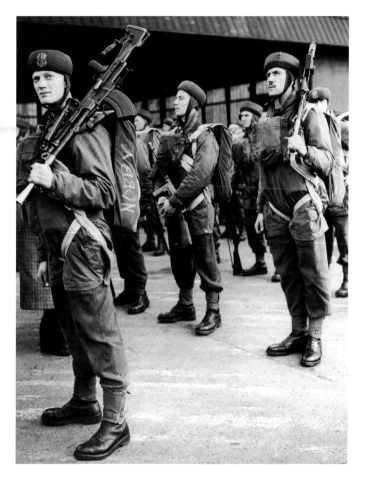

Far left: Men of RAF 601 Squadron Fighter Command load ammunition onto a Bell P-39 Airacobra. On paper, these US-built fighters seemed like ideal reinforcements for Britain's home-built Hurricanes and Spitfires, but in the air their performance was limited and only about 80 of the 675 originally ordered were eventually used by the RAF.
19th October, 1941

Soldiers of the newly formed British Paratroop Regiment prepare for active service. By the end of the Second World War, there would be 17 battalions of airborne infantry in the British army.
20th October, 1941

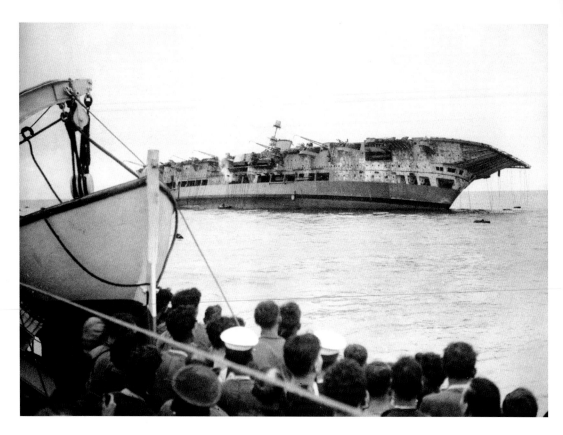

Rescued crew members of HMS *Ark Royal* look on from a lifeboat as the hulk of their aircraft carrier drifts helplessly in Mediterranean waters after having been torpedoed by the German submarine *U-81*.
13th November, 1941

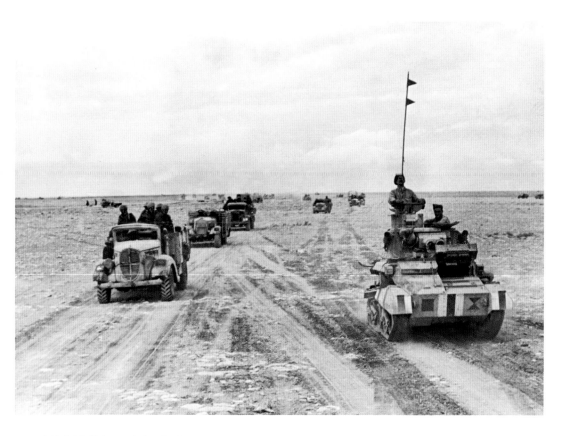

A British light tank leads the way across an
enemy minefield in the Western Desert
of Egypt.
1st December, 1941

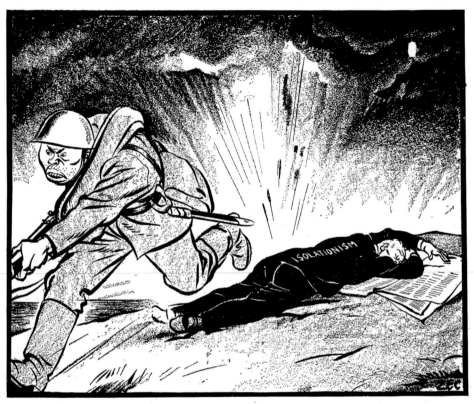

The First American Casualty. *With war undeclared, Japan attacked Pearl Harbour. American Isolationism died in the raid, as the United States lined up with Britain and Russia against the Axis.*

(December 8, 1941)

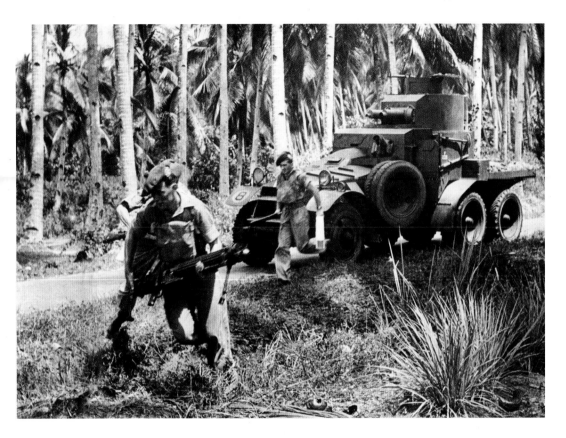

Left: The surprise Japanese attack on Pearl Harbor, Hawaii, drew the United States into a conflict it had tried to avoid through a policy known as Isolationism. This was cartoonist Donald Zec's take on the event in the following morning's *Daily Mirror*.
8th December, 1941

Men of the 2nd Battalion of the Argyll and Sutherland Highlanders patrol a jungle road in Malaya.
19th December, 1941

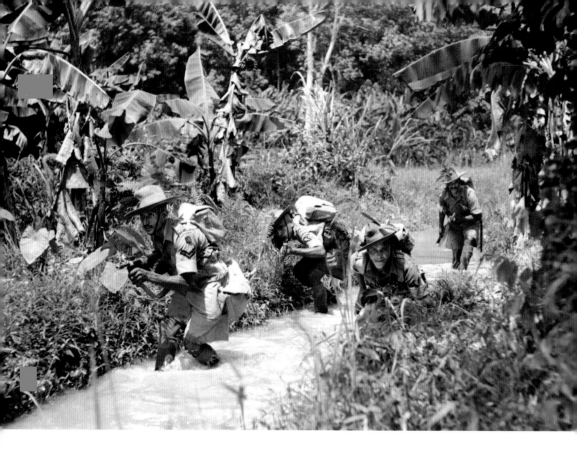

Men of the 9th Gurkha Regiment (Nepalese soldiers of the British army) patrol the Malayan jungle.

20th December, 1941

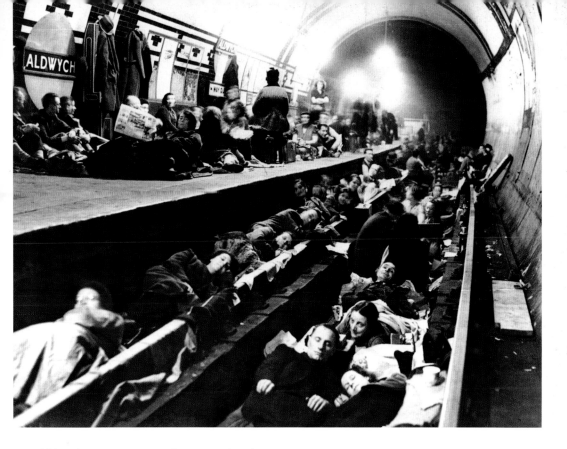

Aldwych was one of many London Underground stations used as air raid shelters during the Blitz, a campaign of sustained strategic bombing of Britain carried out by the Luftwaffe between 7th September, 1940 and 16th May, 1941.
c.1941

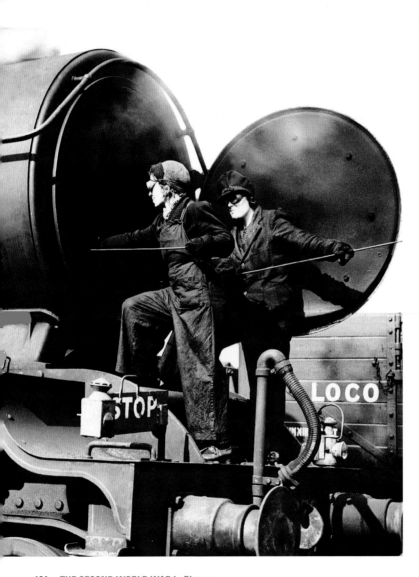
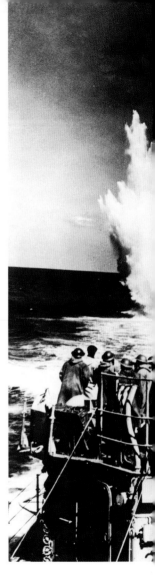

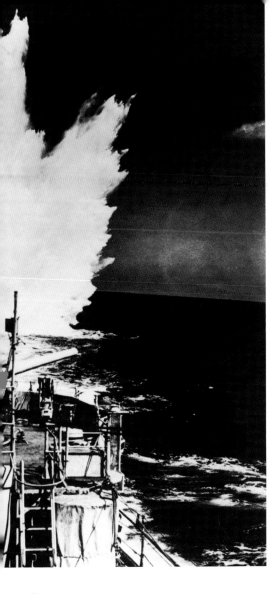

Far left: With so many men away at the front, many of their peacetime jobs were taken over by women, two of whom are here cleaning out the boiler of a steam railway locomotive.
1942

Left: A Royal Navy ship drops depth charges on a German U-boat: Nazi submarines tried to destroy ships on their way from the United States with vital supplies for the British war effort; it was essential that their Atlantic crossings should be undisrupted.
1942

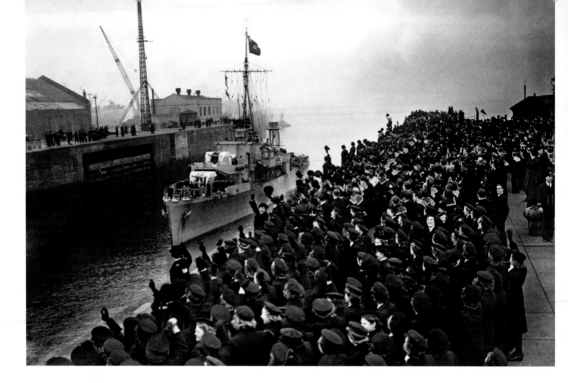

Royal Navy seamen and members of the Woman's Royal Naval Service (WRNS, known universally as 'Wrens') line the entrance to Gladstone Dock in Bootle, Liverpool to greet the return of HMS *Stork*, a Bittern-class sloop commanded by Captain Frederick John Walker, who had just masterminded the destruction of four German U-boats in one of the major Allied victories in the Battle of the Atlantic.
1942

Right: Members of the Auxiliary Territorial Service (ATS) wearing full gas equipment train on range finders at a London gun site. With war looming, the ATS was formed in September 1938 as a women's voluntary service.
1942

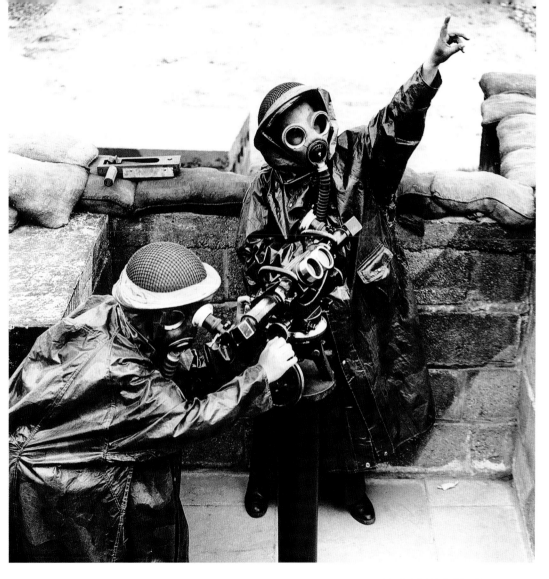

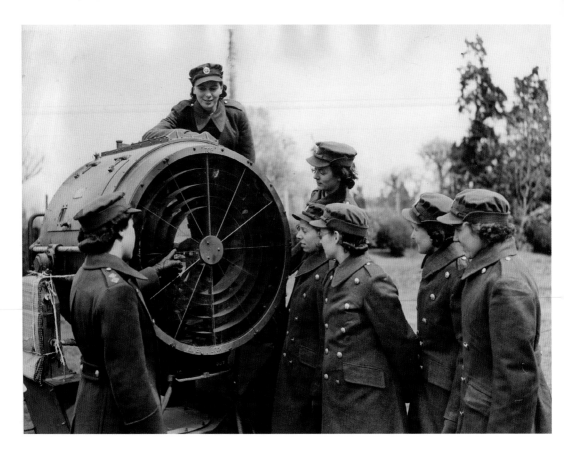

Six ATS are taught how to operate a searchlight: these were the first women to be put in charge of this method of picking out enemy aircraft in the night sky so that gun emplacements could shoot them down.
May 1942

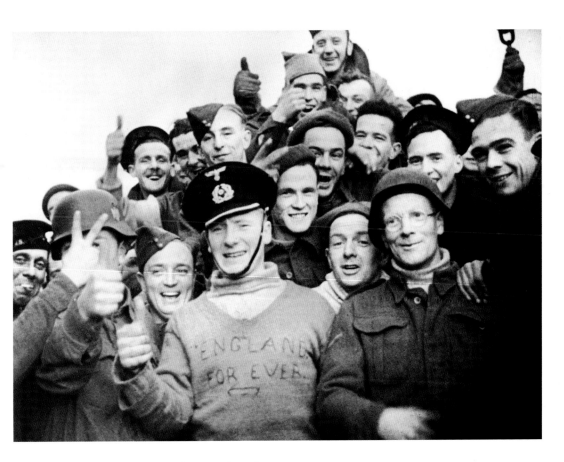

British servicemen return home after the successful completion of Operation Archery (27th December, 1941), in which they recaptured Vaagso Island in Norway.
3rd January, 1942

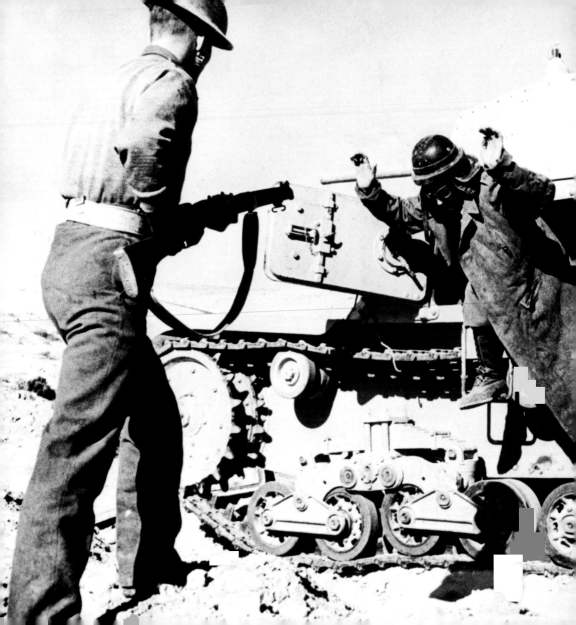

A member of the crew of a captured Italian tank surrenders to a British infantryman after the Allies' capture of Cyrenaica in eastern Libya.
5th January, 1942

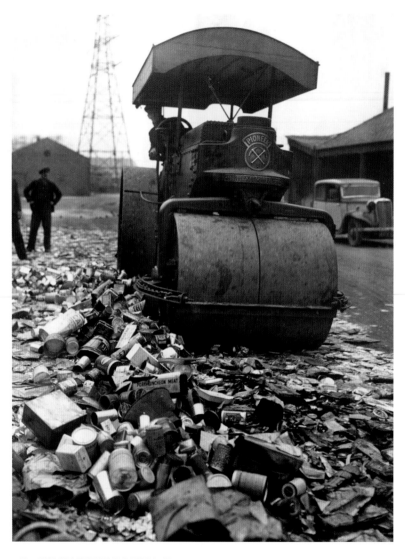

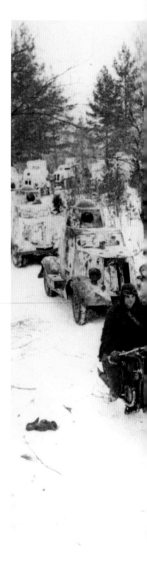

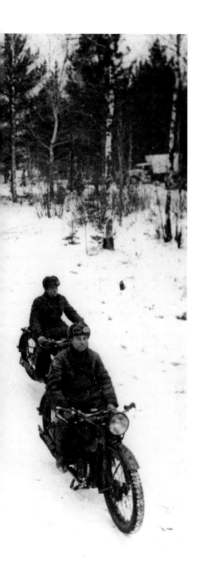

Far left: Piles of tin and aluminium cans are crushed by a giant steamroller for salvage as part of the British effort to recycle used metal.
18th January, 1942

On the Eastern Front, the tide turned in the winter of 1941 and the Soviet Union began to drive the Nazis back. Here Soviet motorcyclists and armoured cars advance to reclaim invaded territory.
February 1942

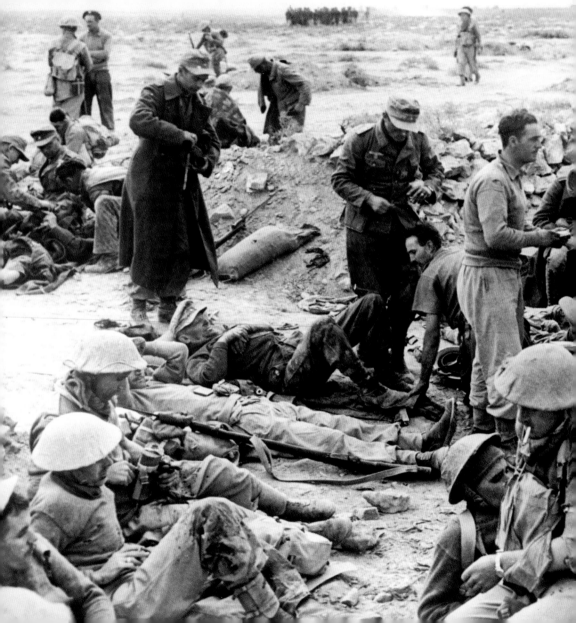

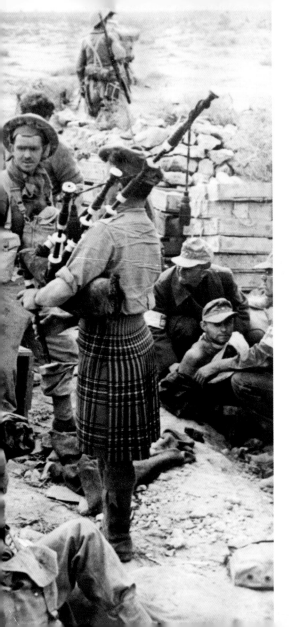

A Highland piper entertains wounded Allied and Axis soldiers at a casualty clearing station.
February 1942

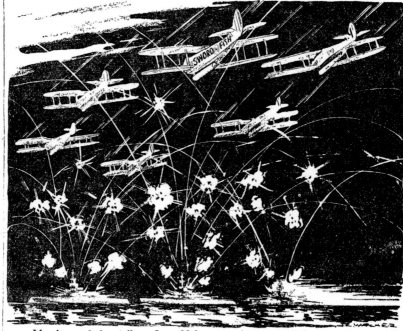

CARTOON - - - - - - - - - - - By J. C. WALKER

Valour That Will Bring Final Victory

Members of the gallant Swordfish crews (not one of the aircraft returned) have been awarded medals for valour.

J.C. Walker's cartoon pays tribute to the crews of six Swordfish that were among the 42 RAF aircraft lost in the unsuccessful British attempt to intercept three German battleships – *Scharnhorst*, *Gneisenau* and *Prinz Eugen* – as they made 'the Channel Dash' from Brest, France, to their home ports.

14th February, 1942

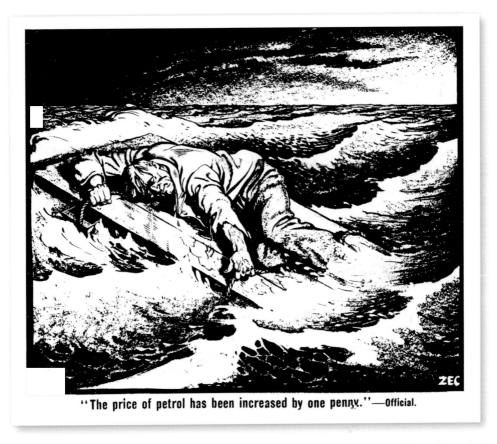

"The price of petrol has been increased by one penny."—Official.

This Donald Zec cartoon caused outrage when it appeared in the *Daily Mirror*. It was intended as a criticism of profiteering, but the authorities – including Churchill – regarded it as the work of a traitor.
6th March, 1942

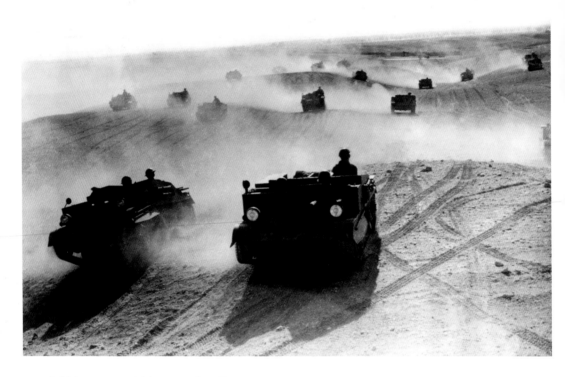

British army vehicles carrying Bren guns across the sands of the North African desert.
18th March, 1942

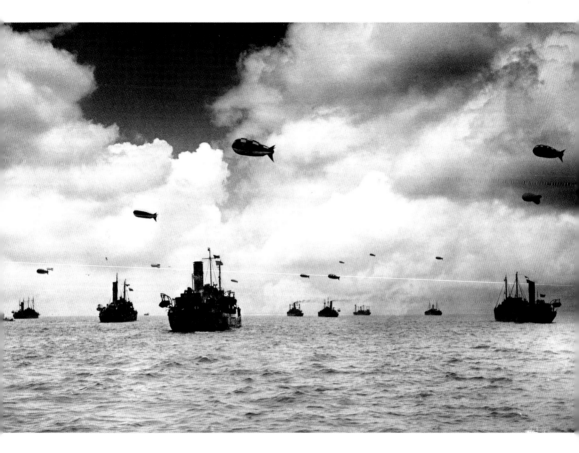

Barrage balloons were large inflatables that were flown on fixed lines to disrupt attacks by hostile aircraft. Kite balloons were smaller variants that were tied to ships for the same purpose. When this photograph was taken they had accounted for at least six enemy aircraft and saved more than 200 ships during air attacks on coastal traffic around Britain.

April 1942

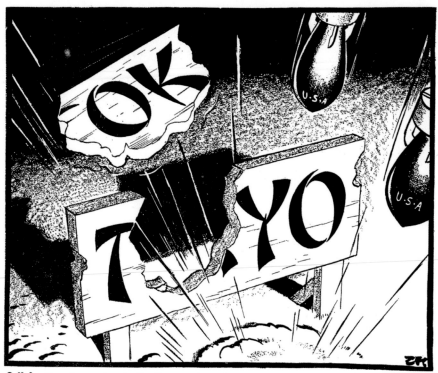

O.K.! *The grim news from the Far East was brightened by the news of General Doolittle's gallant carrier-borne raid on Tokyo on April 18.*

(April 21, 1942)

Lieutenant Colonel James Doolittle's mission (18th April, 1942) was the first US air attack on mainland Japan since Pearl Harbor. Although it had limited strategic significance, the Doolittle Raid helped to undermine Japanese feelings of invincibility and brought a welcome boost to Allied morale, as this *Daily Mirror* cartoon shows.

21st April, 1942

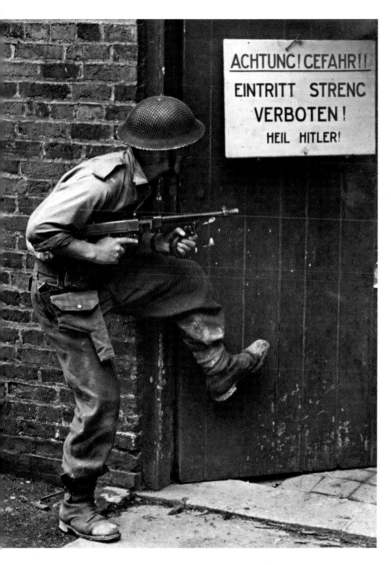

ACHTUNC! CEFAHR!!
EINTRITT STRENC
VERBOTEN!
HEIL HITLER!

During combat training, a British soldier armed with a Thompson submachine gun (Tommy gun) prepares to storm a mock-up of a German building.

25th May, 1942

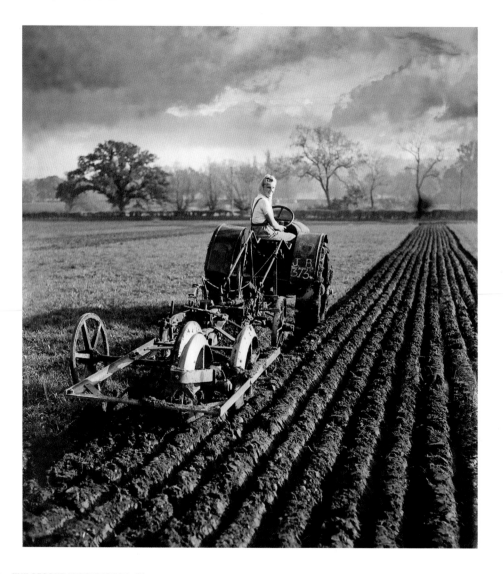

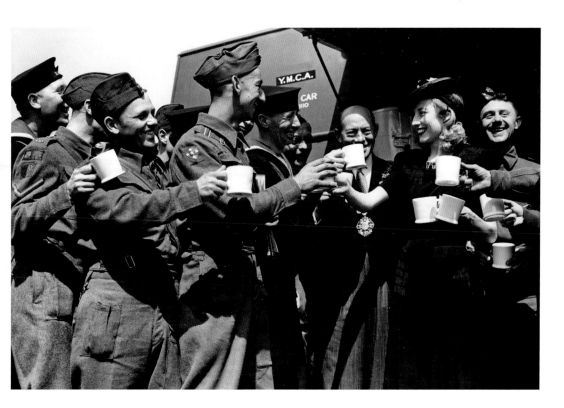

Left: The Women's Land Army (WLA) was a civilian organisation originally formed in 1915 to recruit women to take on agricultural labour previously carried out by men who were away fighting in the trenches. Revived in the Second World War, its members were known colloquially as Land Girls. Here one of them ploughs a field in Berkshire.
June 1942

Popular singer Vera Lynn – known as 'The Forces' Sweetheart' – presents the Mayor of Westminster with a mobile canteen and serves the first cups of tea from it herself to servicemen in London's Trafalgar Square.
4th June, 1942

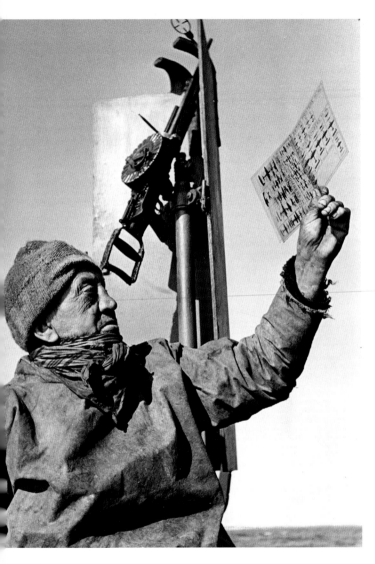

Who goes there: friend or foe? On the deck of his trawler, a fisherman holds up an aircraft recognition chart to see if there's trouble overhead.

1942

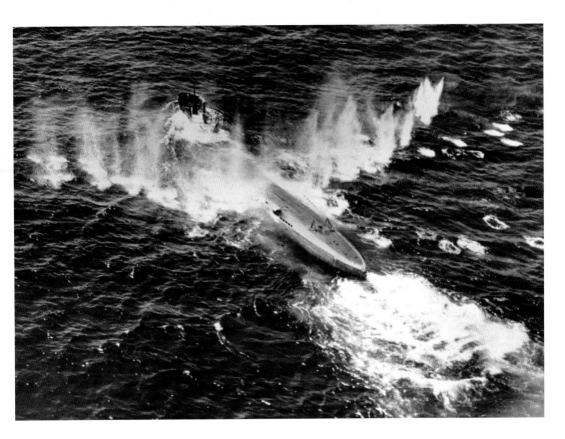

Having surfaced in the Bay of Biscay, a German U-boat is caught in a hail of gunfire and bombs dropped from a Short Sunderland flying boat of RAF Coastal Command.
19th June, 1942

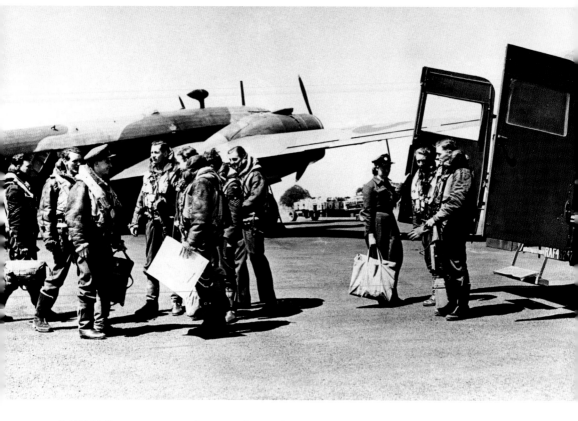

RAF Wellington crews arrive at a dispersal point before going off on a bombing raid over enemy territory. The van in which they have come is driven by a member of the Women's Auxiliary Air Force (WAAF).
26th June 1942

Right: Red Army soldiers fire at German tanks during the Soviet advance across western Russia.
July 1942

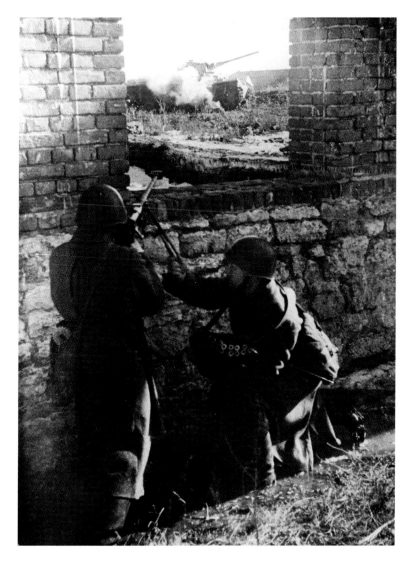

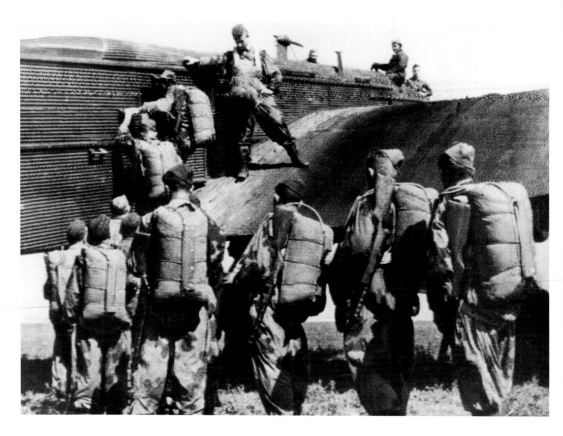

A group of Soviet parachutists boarding a plane during drills before joining guerrillas fighting against the German army on the Eastern front.

7th July, 1942

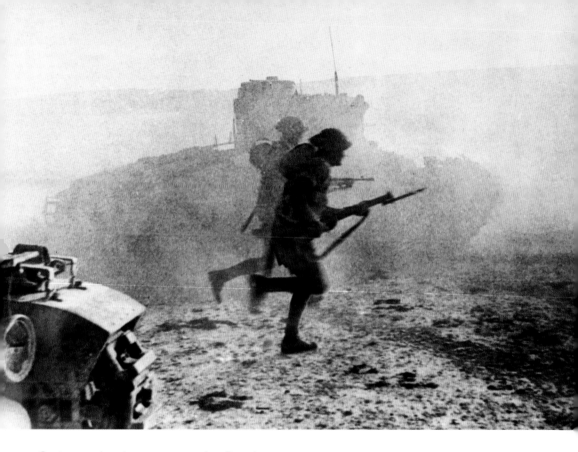

Scots guards advance across the Egyptian desert under cover of a smoke screen and the dust thrown up by nearby tanks during the First Battle of El Alamein.
14th July, 1942

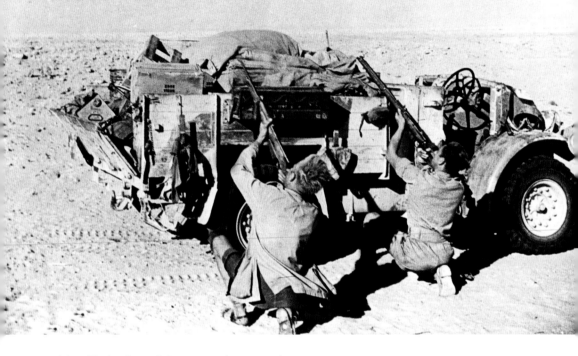

New Zealanders of the reconnaissance unit Long Range Patrol (later the Long Range Desert Group) take cover behind their truck at El Alamein while firing at German Stuka dive bombers that had attacked their convoy.
20th July, 1942

Right: A British infantryman takes cover as a 2,000-pound (907kg) bomb explodes near the front line on the ridge of Tel el Eisa near El Alamein.
24th August, 1942

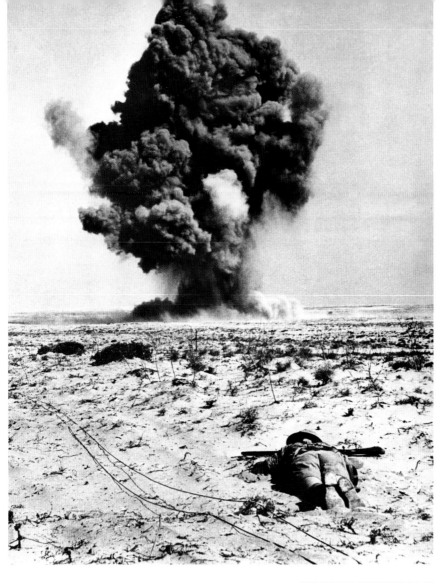

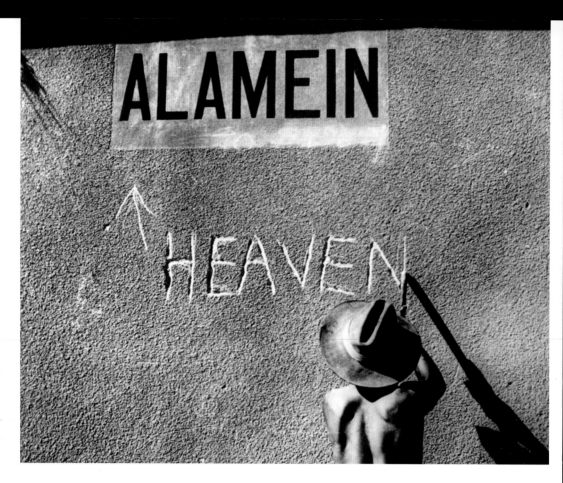

An Australian soldier makes his mark on a
wall outside the Allied encampment.
30th August, 1942

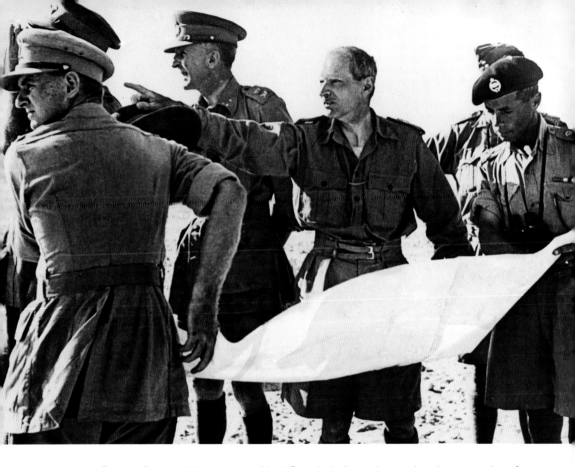

Lieutenant-General Bernard Montgomery (third R, pointing), newly appointed commander of the British Eighth Army in North Africa, explains his tactics to officers of the 22nd Armoured Brigade. To Monty's right is Lieutenant-General Brian Horrocks.
31st August, 1942

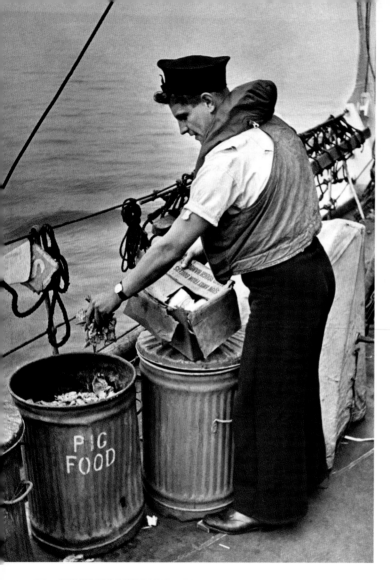

Left: Waste not, want not. A seaman aboard HMS *Destroyer*, on convoy duty off the British coast in the North Sea, places reusable material in metal bins.
August 1942

Land Girls baling on a farm. The connotations of 'a roll in the hay' and the attractive swimming costumes will not have been lost on contemporary viewers.
August 1942

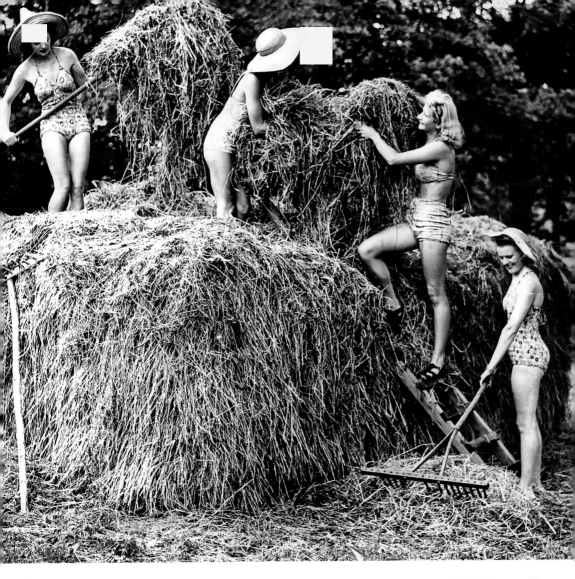

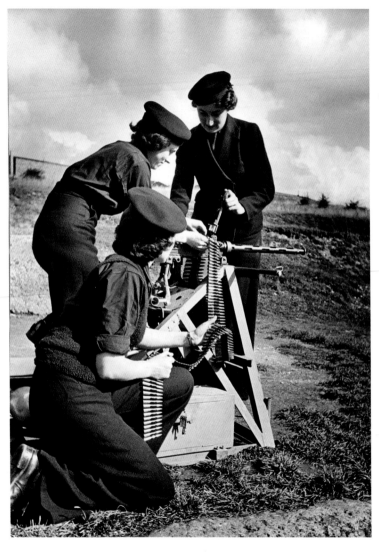

Wrens preparing a turret gun for testing. During the Second World War the recruiting slogan was 'Join the Wrens – free a man for the fleet'.

September 1942

Wrens attached to the Fleet Air Arm putting a wireless into the cockpit of a Westland Lysander shortly before one of them, Pat Lees, became the first woman to fly for the British forces.
September 1942

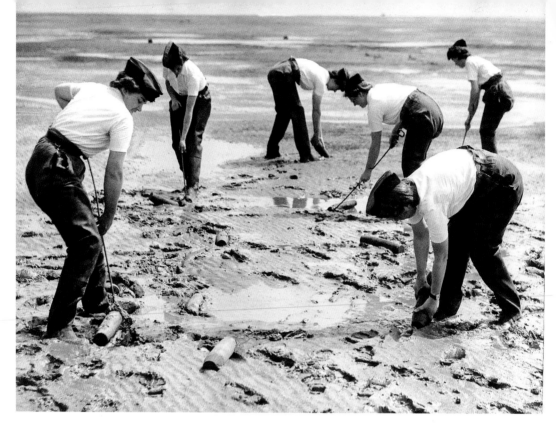

ATS girls gather shells at an Experimental Establishment of the Ministry of Supply.
1942

Right: As the Second World War entered its fourth year, reinforcements were welcome to the Allied forces. Here US army troops leave Green Street, Mayfair for their march across the British capital to Mansion House in the City of London.
2nd September, 1942

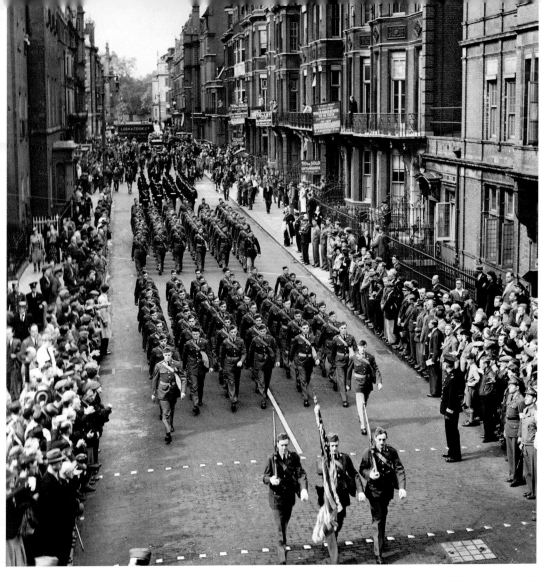

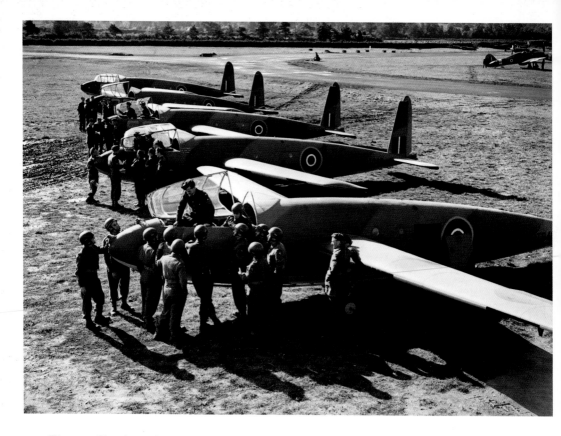

The conflict brought an unusually large amount of crossover between the different branches of the armed forces. Here an RAF instructor teaches army personnel about gliders.

9th October, 1942

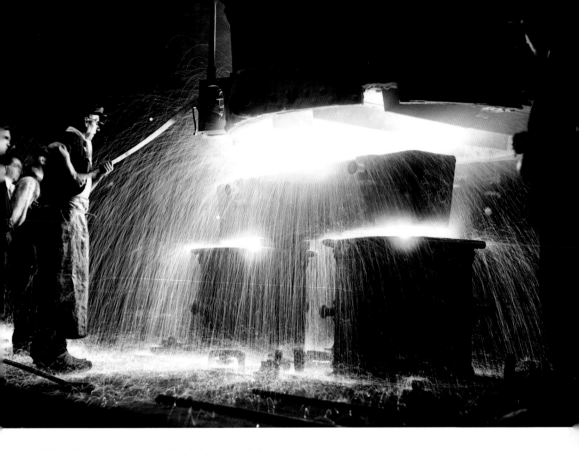

Britain's steelworks worked day and night to produce motors, guns, armour and many other products for the war effort. Some of them used as much as 10,000 tons (101,600kg) of coal a week to feed their furnaces.

14th October, 1942

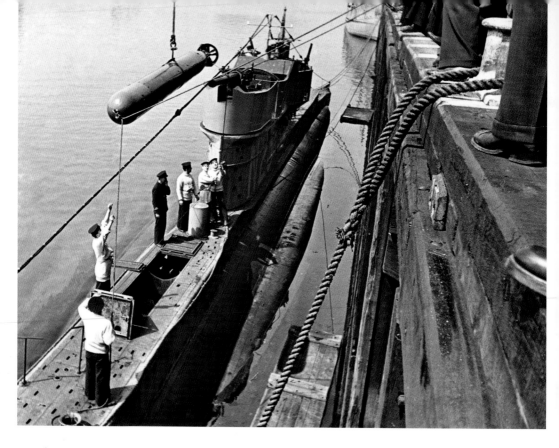

Sailors manoeuvre a torpedo from a winch towards its mounting on a submarine during training at a Royal Navy base.
14th October, 1942

Right: A Grumman F6F *Hellcat* fighter prepares for take-off from an aircraft carrier.
17th October, 1942

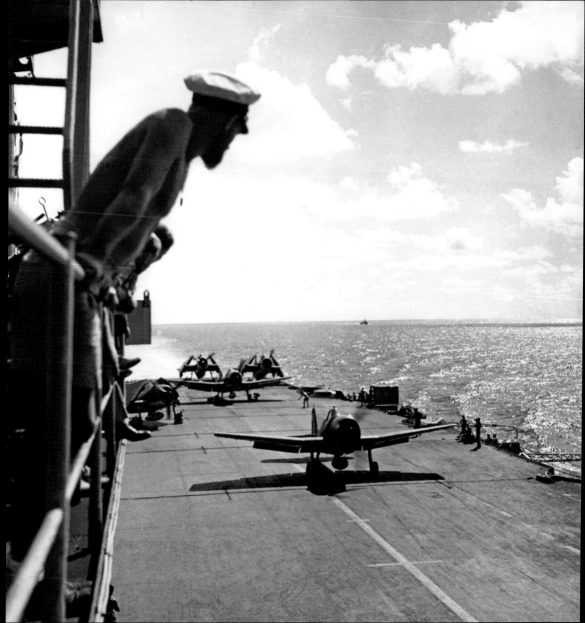

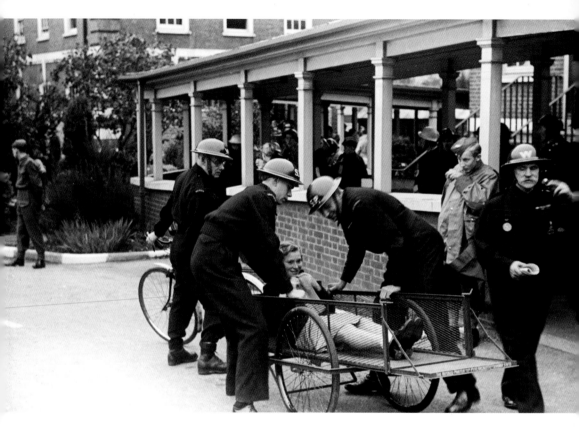

Civil Defence Wardens carry out Invasion
Exercises in Kingston upon Thames, Surrey.
25th October, 1942

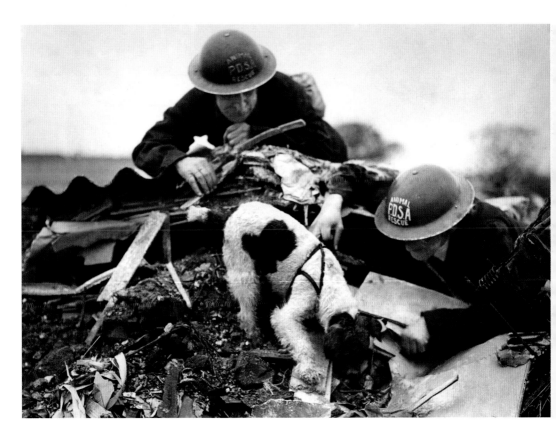

One good turn deserves another: a homeless
dog rescued by the People's Dispensary for
Sick Animals (PDSA) burrows in the rubble
of a bomb-damaged building for signs of life.
November 1942

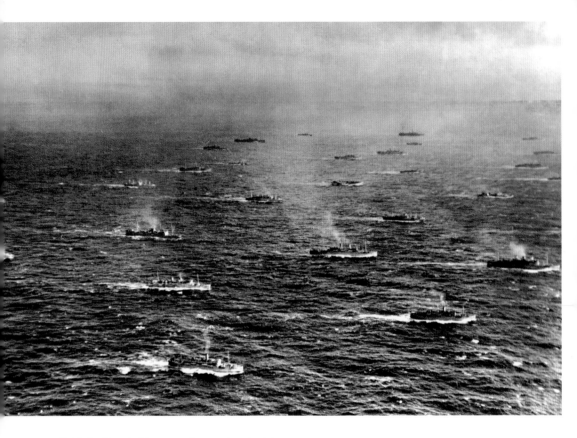

British Royal Navy and merchant ships bound for the coast of North Africa with reinforcements and supplies for the Eighth Army.
November 1942

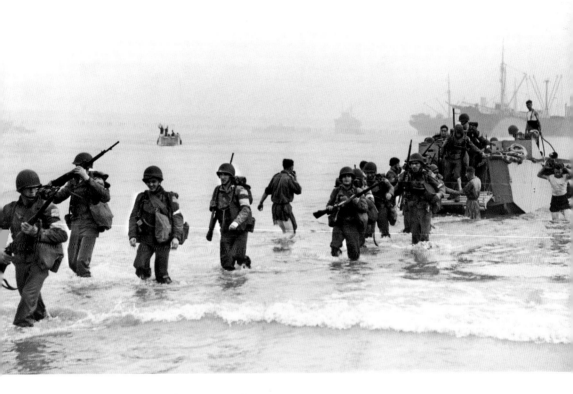

American troops land at Arzew near Oran,
Algeria at the start of Operation Torch, part
of the Allied offensive to drive the Axis out
of North Africa and make the Mediterranean
safe for the planned invasion of Italy.
8th November, 1942

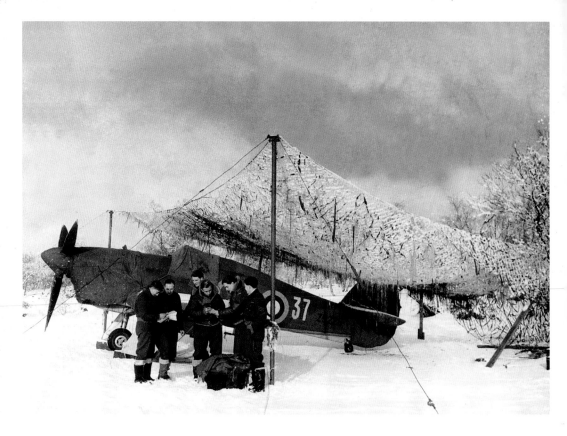

Part of Britain's contribution to the Soviet war effort: an RAF Hurricane in a snow-covered field in Russia.
16th November, 1942

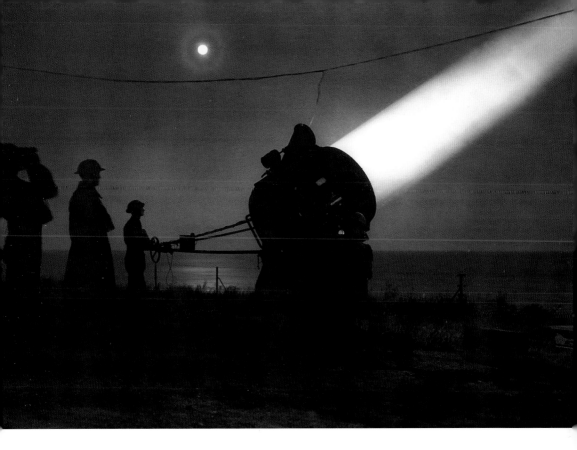

A British army searchlight crew scans the night sky for enemy aircraft.
c.1942

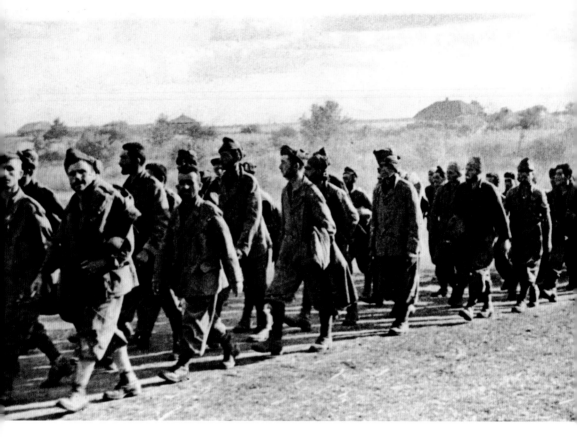

Italian prisoners of war are marched under armed guard to a prison camp after their capture by Soviet troops.
27th November, 1942

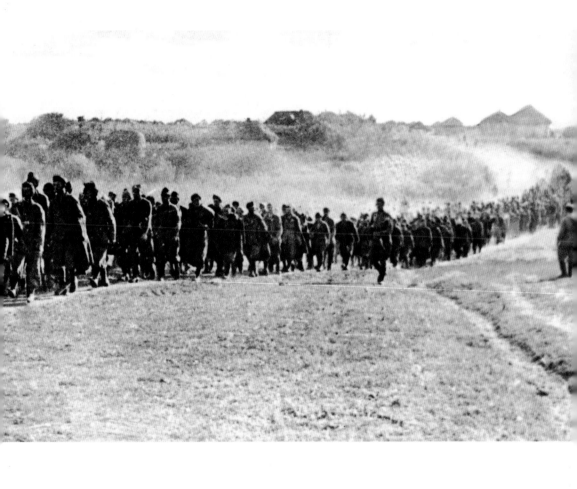

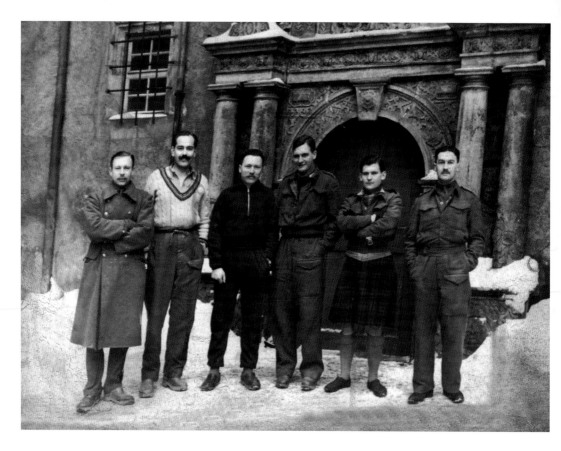

British prisoners of war at Colditz, a castle near Leipzig, Germany that became a top-security internment camp for Allied servicemen who had previously tried to escape from other jails. (L–R) Captains Harry Elliot, Rupert Barry, Pat Reid and Dick Howe; Second Lieutenant Peter Allan and Captain Kenneth Lockwood.
c.1942

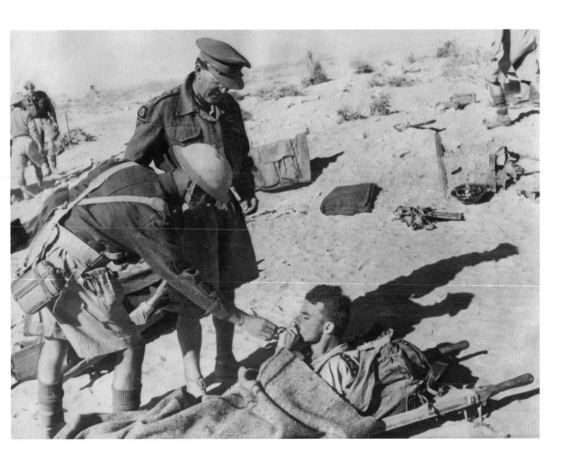

A Scottish soldier gives a drag of his cigarette to a wounded Italian captured by the British on the first day of the Second Battle of El Alamein.
23rd October, 1942

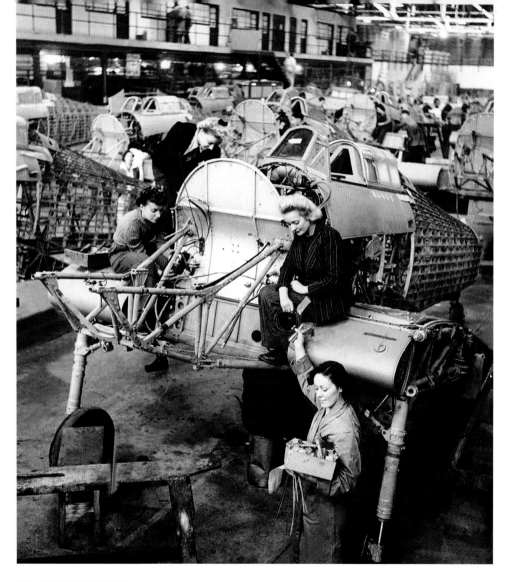

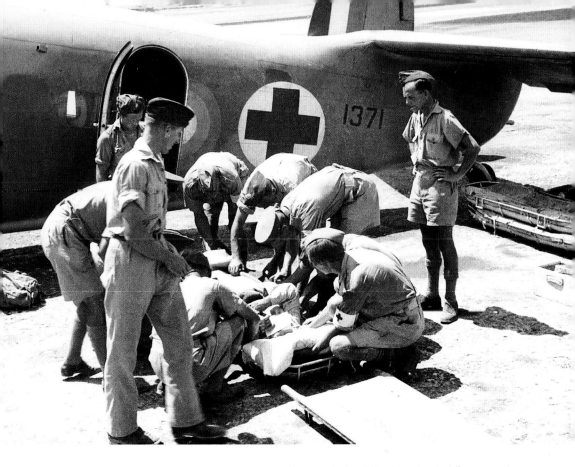

A wounded soldier is unloaded from an air ambulance of the Royal Australian Air Force in Malta after a flight from Sicily.
1943

Left: Women work on the production line of Hawker Hurricane fighters.
c.1942

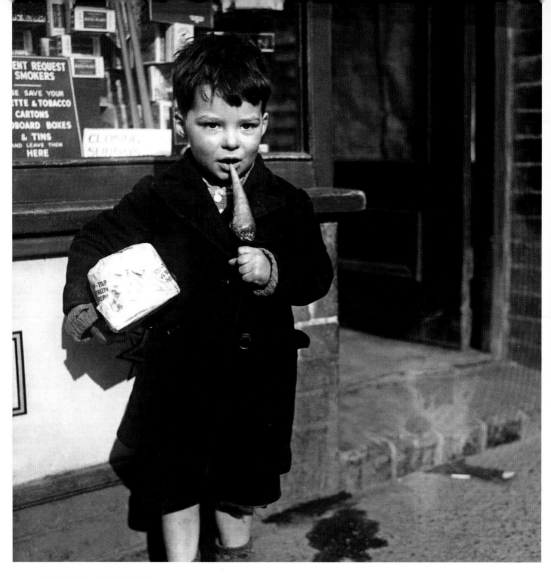

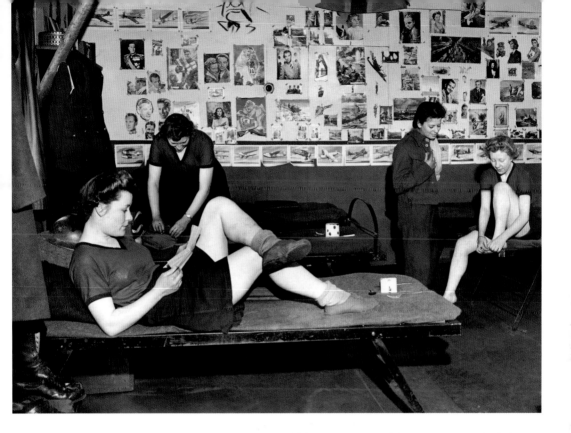

ATS girls on a Welsh gun site call their barrack room 'the Beehive'. The walls are covered with pictures of film stars and other celebrities.

12th January, 1943

Left: A young boy holds a loaf of bread and a toffee carrot, which in the absence of the traditional toffee apples because of rationing, was the best sweet the shopkeeper could offer him.

1943

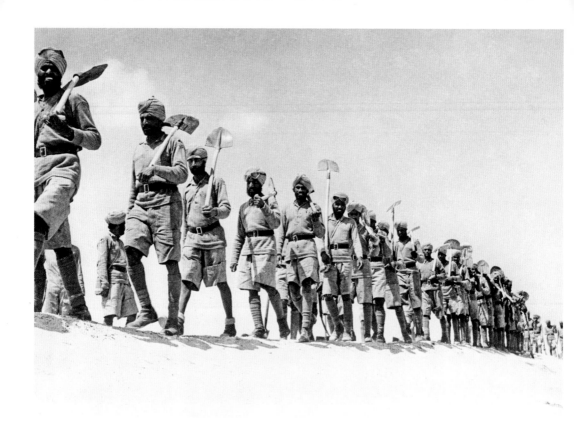

Shovels at the ready, sappers and miners of
the Indian Army march to a spot where they
will dig in in the Western Desert.
7th February, 1943

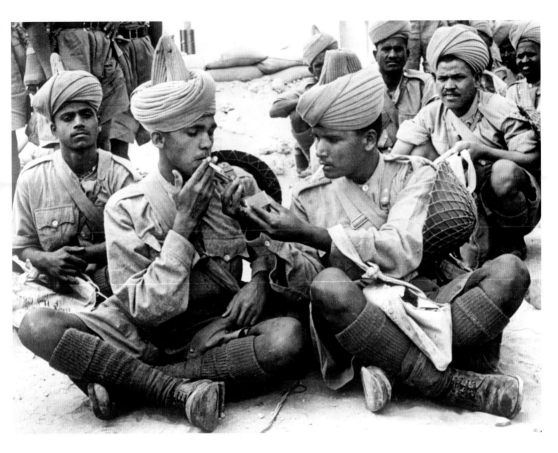

Time to relax: having reached the spot, the Indians take time out for a quick cigarette before getting down to business.
7th February, 1943

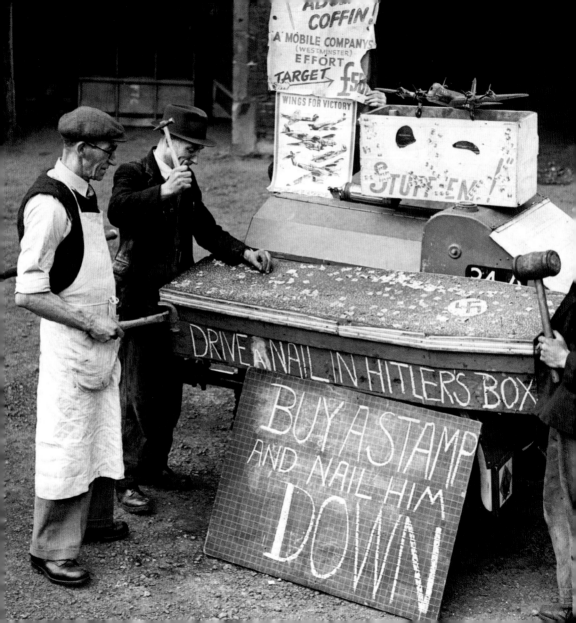

Wings for Victory Week was a fund-raising scheme to encourage civilians to save their money in government accounts such as War Bonds, Savings Bonds, Defence Bonds and Savings Certificates. The promotion shown here raised £3,418.

17th March, 1943

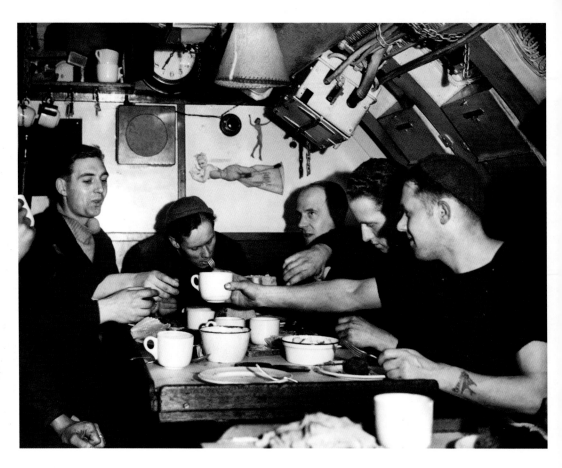

The war beneath the waves: submarine crew members gather in their cramped mess room for a meal. They tend to eat at times that would be regarded as odd on shore, but life is different underwater.

4th April, 1943

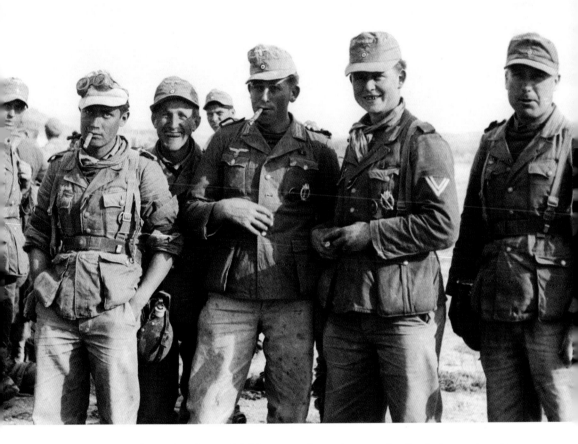

German soldiers of the 15th Panzer Division pose for a photograph after being captured by Allied forces at Gabès Gap during the Battle of Wadi Akarit in Tunisia on 6th-7th April.
15th April, 1943

A specially adapted Avro Lancaster seen here carrying out a live testing of a Barnes Wallis bouncing bomb off the coast at Reculver, Kent. Shortly after the test, bombers from 617 Squadron of the RAF took part in Operation Chastise (16–17th May), which breached the Möhne and Eder dams in the Ruhr Valley of Germany.
May 1943

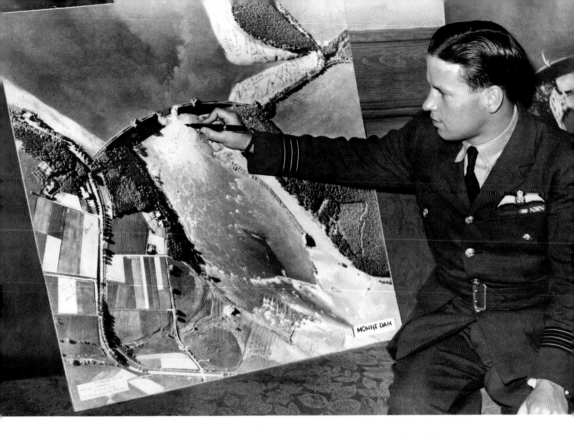

MOHNE DAM

Left: Air Marshal Arthur Harris (R), Commander-in-Chief of RAF Bomber Command from February 1942, chats with two Air Commodores. He became known as 'Bomber' Harris because of the zeal with which he ordered raids on German cities in the latter stages of the Second World War.
10th May, 1943

Wing Commander Guy Gibson, who led the Dambusters Raid and was awarded the Victoria Cross for his valour.
22nd June, 1943

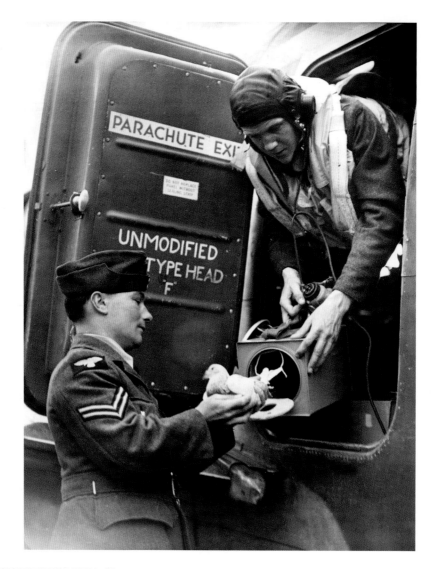

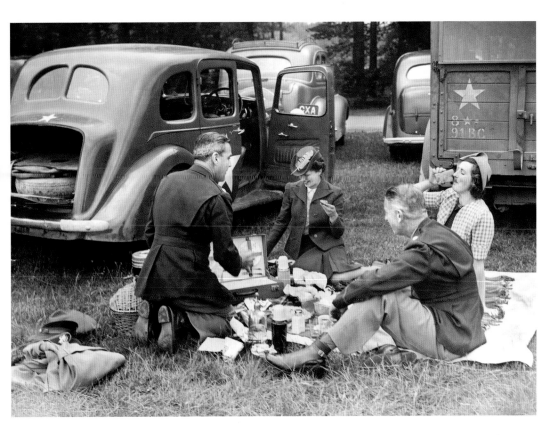

Left: An RAF pilot takes a carrier pigeon on board his Halifax bomber before a raid. Birds like this one were useful in the event of the aircraft's radio being disabled because they could fly home to base with a message.
6th June, 1943

American soldiers enjoy a picnic with their English girlfriends during a day out to watch the Derby. The annual flat race for three-year-old horses was moved to Newmarket from its traditional location at Epsom for the duration of the Second World War.
20th June, 1943

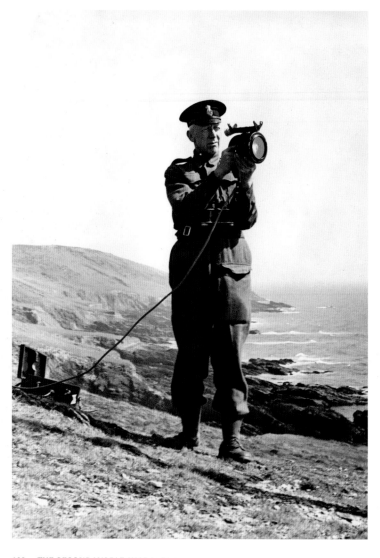

Coastguard officer Richard Rowsell scans the South Devon coast for any jetsam that might be valuable or of interest to military intelligence. He is holding an Aldis lamp, which was used to communicate by Morse code signals back to base. **c.1943**

WAAF mechanics messing about on the tail
of a Hurricane fighter.
June 1943

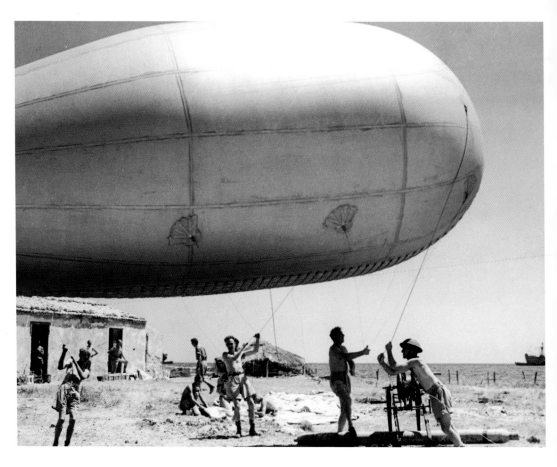

On the first day of Operation Husky, the Allied landings in Sicily, the RAF loses no time in establishing its base there, setting up balloon defences against aerial counter-attack. 10th July, 1943

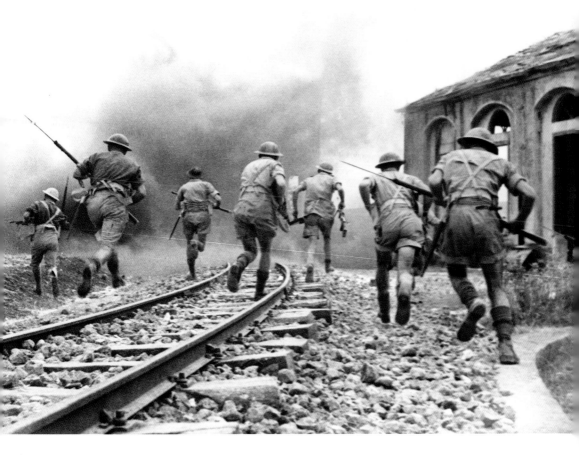

As the Allies fight their way through Sicily,
soliders of the Eighth Army move inland to
capture a railway station.
9th August, 1943

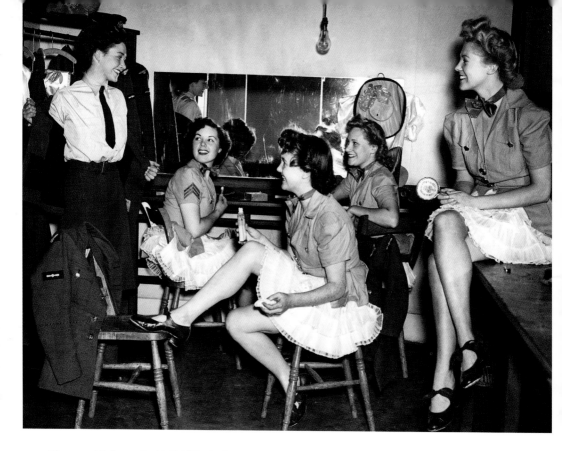

Chorus girls from the WAAF in their dressing room at the Phoenix Theatre, London, during rehearsals of *This is the Gen*, a review in aid of the RAF Benevolent Fund.

29th August, 1943

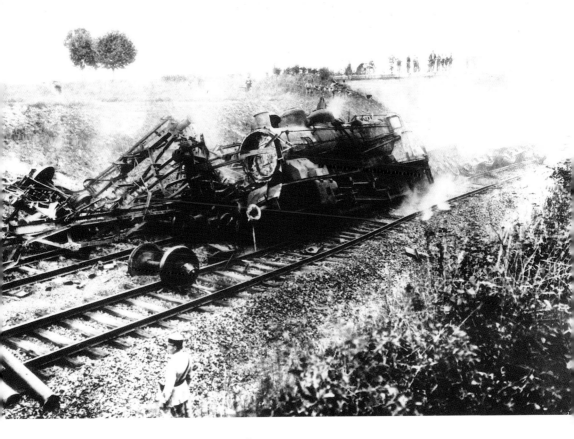

The wreckage of a train carrying gasoline that had been attacked the previous night by members of the French Resistance near Varennes-le-Grand.

1st September, 1943

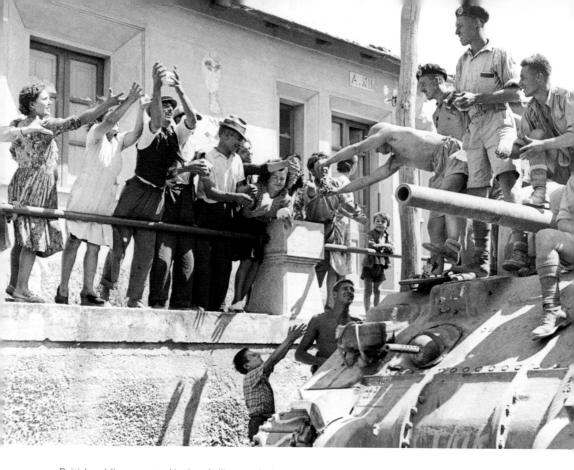

British soldiers greeted by local villagers during
the Allied invasion and liberation of Italy.
12th September, 1943

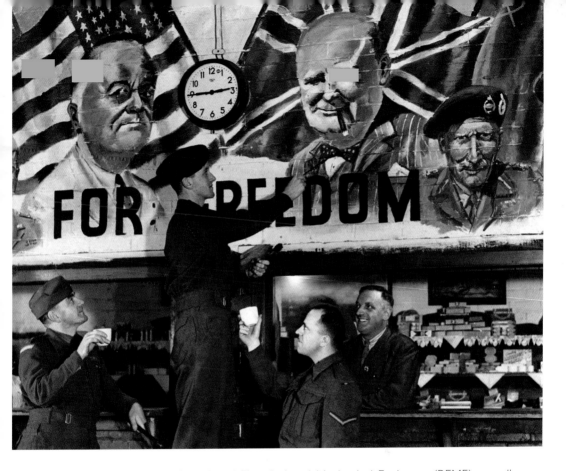

Private Malcolm Haylett of the Royal Electrical and Mechanical Engineers (REME) proudly displays his mural in a Navy, Army and Air Force Institutes' (NAAFI) canteen in northern England. His work features some of the great Allied wartime leaders: (L–R) US President Franklin D. Roosevelt, British Prime Minister Winston Churchill and Field Marshal Bernard Montgomery.

21st September, 1943

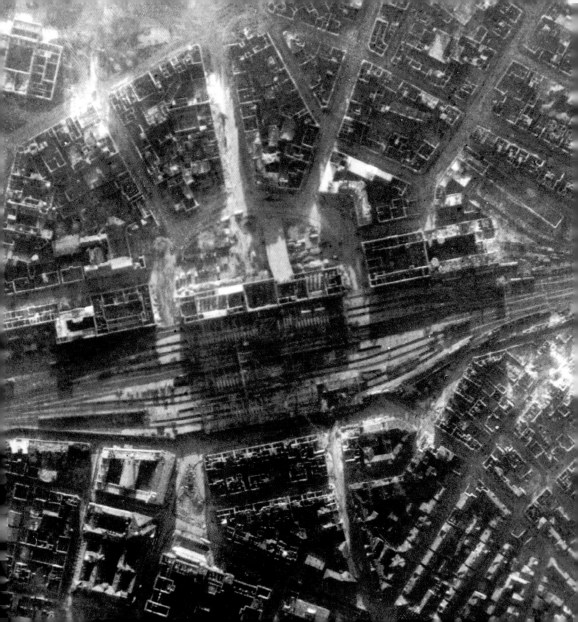

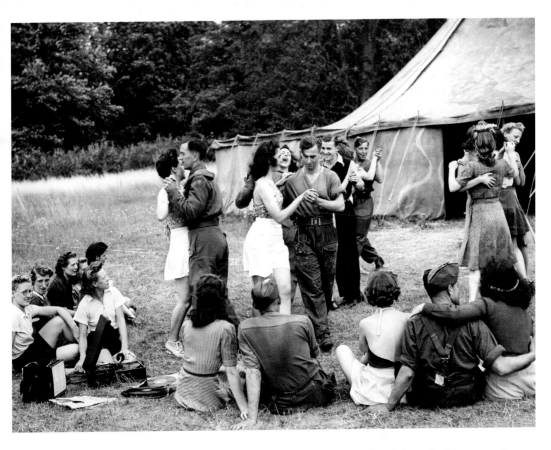

Dance time at a Land Army holiday camp in Cookham, Berkshire.
7th October, 1943

Left: An aerial view of damage to the German city of Hannover after an RAF bombing raid.
October 1943

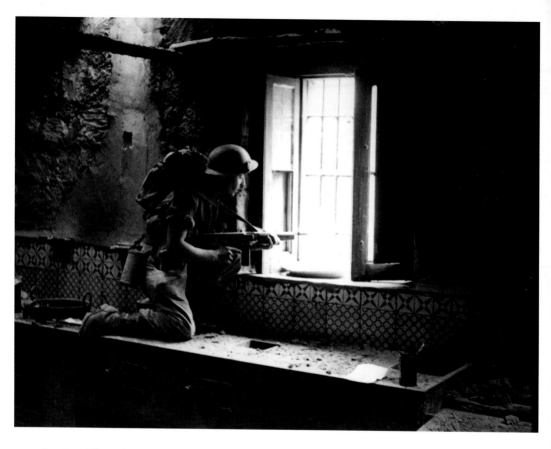

As the Allies advance north through Italy, a soldier of the Eighth Army fires from a window in Naples.
10th October, 1943

As the British arrive with their tanks in Cava de' Tirreni, Campania, southern Italy, a local woman gets her cigarette lit by a soldier of the Fifth Army.
13th October, 1943

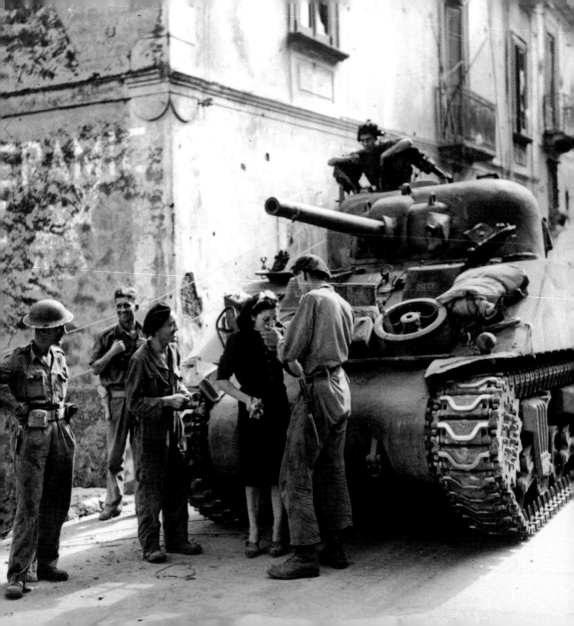

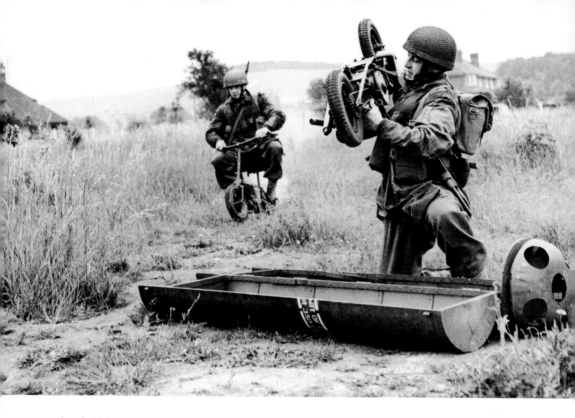

A British paratrooper assembles his Welbike – a light folding motor scooter capable of up to 45mph (72km/h) and so named because it was a bicycle developed in Welwyn, Hertfordshire.
10th November, 1943

Right: A happy moment on a grim front; two volunteer women snipers of the Soviet Red Army return from a combat assignment.
21st November, 1943

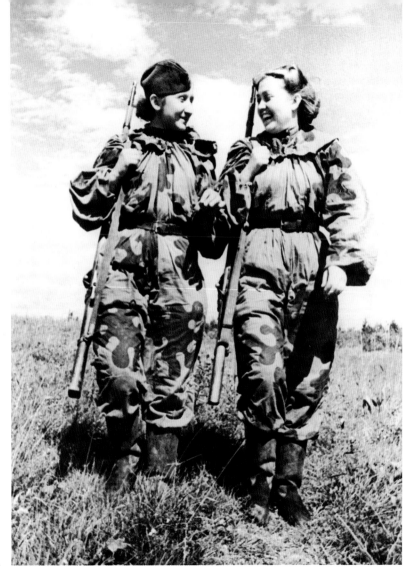

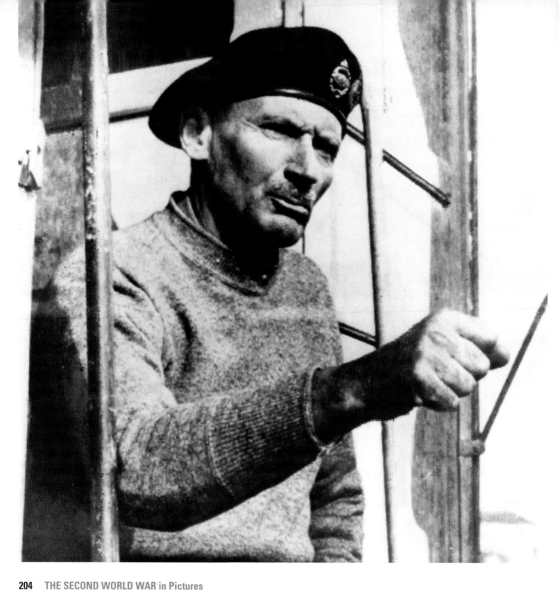

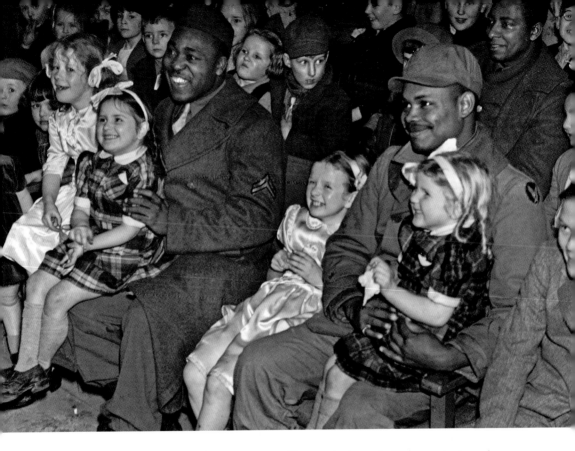

Left: Field Marshal Bernard Montgomery pulled no punches during the Italian campaign, which he thought was deplorably organised and which he described as 'a dog's breakfast'. He was delighted to leave three weeks after this photograph was taken.

4th December, 1943

The greatest good of the greatest number: US soldiers endear themselves to local children while they all enjoy a film at a local British cinema.

22nd December, 1943

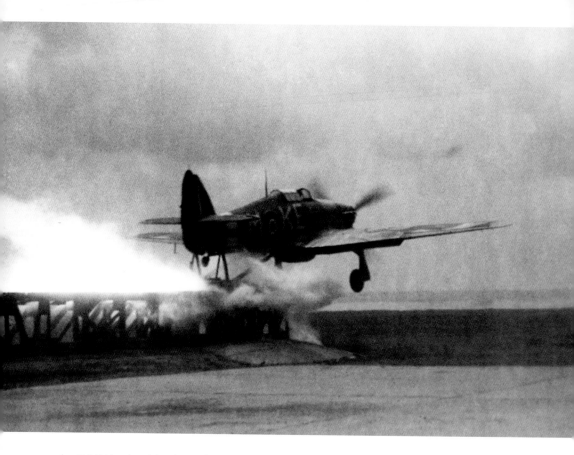

An RAF Hawker Hurricane is catapulted from the bow of a merchant ship. Unable to land back on board and too far from land to make it to an airfield, it would later ditch in the sea near the mother ship and be hoisted back on board.
c.1943

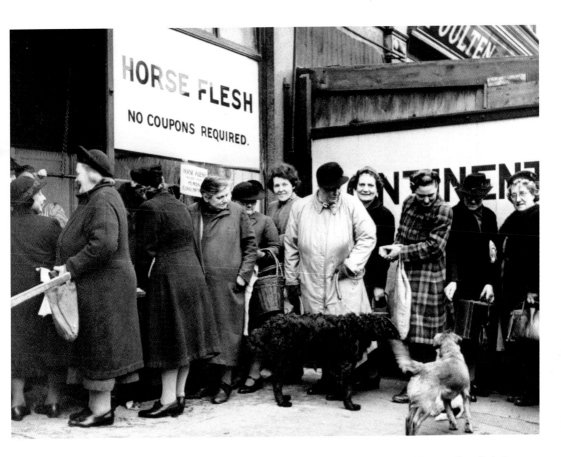

Women queue for horsemeat, one of the few foods that was not rationed in wartime Britain. As the conflict dragged on, there was less and less choice of things to eat, and much of what was available was in short supply. The first things to run out were imported goods such as tea, bananas, oranges and grapes. By the end of the war butter, lard, sweets, flour, sugar and eventually fish and meat were becoming hard to find.

c.1943

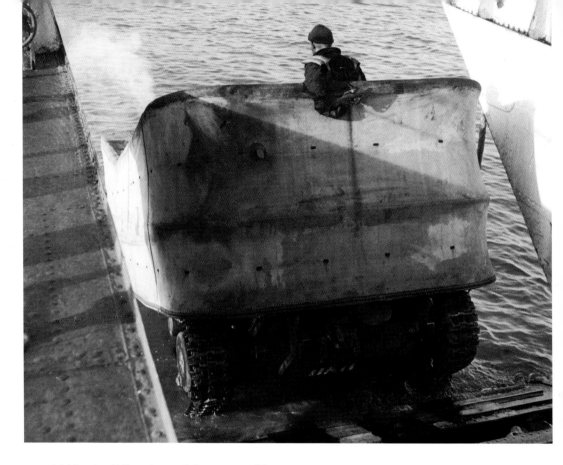

A Valentine DD tank, specially converted for amphibious use, leaves the ramp of a landing craft and enters the sea almost two miles (3km) from shore during a training exercise ahead of the D-Day landings.
c.1944

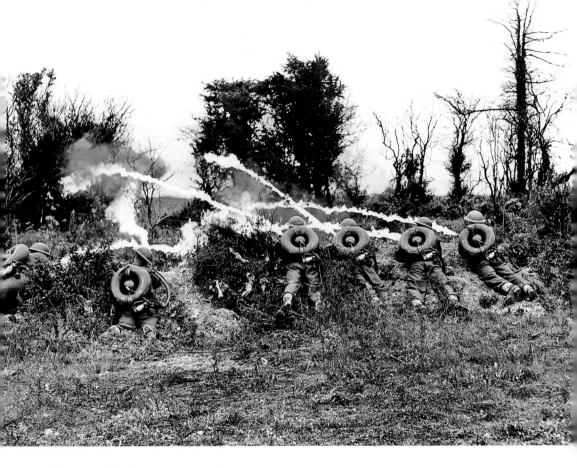

British troops fire flamethrowers at Japanese bunkers. These weapons were nicknamed 'lifebuoys' after the shape of their fuel tanks, which were carried on the soldiers' backs.
c.1944

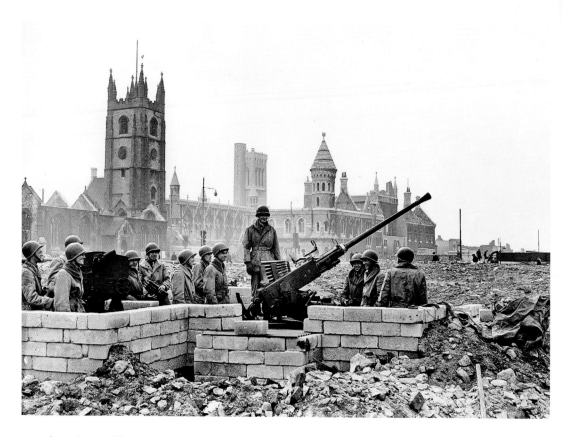

American soldiers man an anti-aircraft (ack-ack) gun in Plymouth, an important port in Devon that was frequently targeted by Lutfwaffe bombing raids.

c.1944

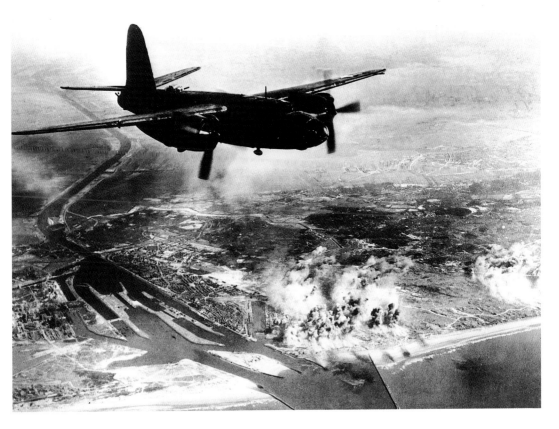

A B26 Marauder of the US 9th Air Force turns for England after a successful attack on the E-boat pens at Ijmuiden on the Dutch coast. The aircraft was one of 350 bombers on the raid. Only one did not return. (E-boats were German attack vessels; the 'E' stood for 'enemy'; in German they were known as S-boote – 'S' for schnell, meaning 'fast'.)
c.1944

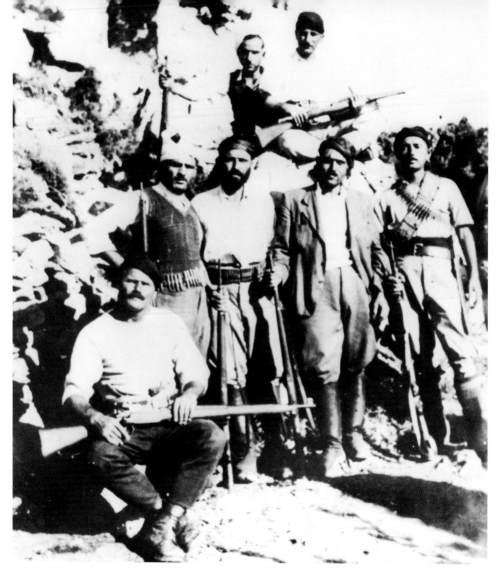

Leap Year.

This cartoon opened the Year of Invasion . . . the year the world had waited for since 1940.

(January 1, 1944)

53

Left: Greek guerrillas in the mountains of Crete wearing the islanders' traditional headdresses and boots.

c.1944

Everyone knew it was coming this year, an Allied invasion of Europe from England, but no one yet knew exactly where or when.

1st January, 1944

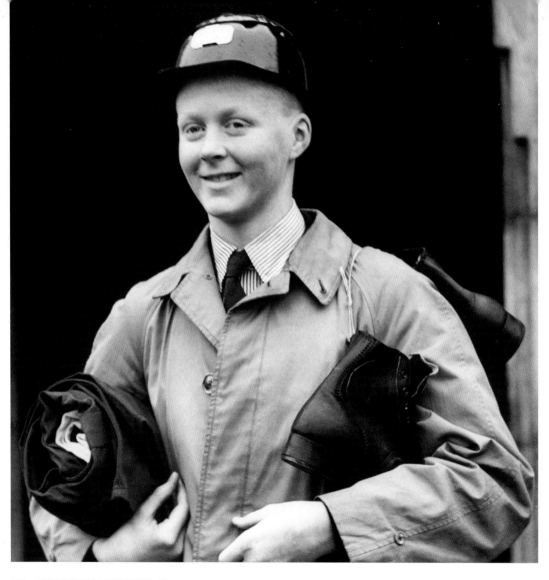

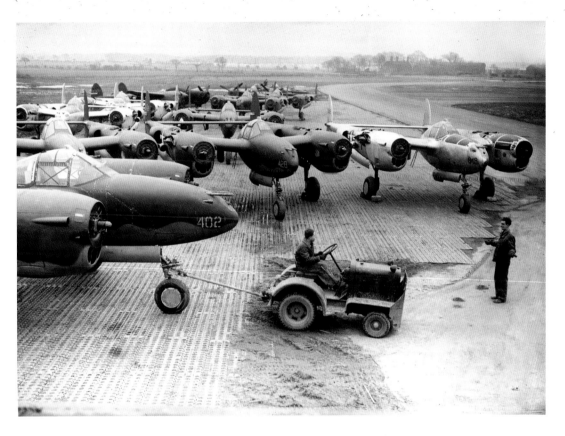

Left: Anything to help the war effort. Eighteeen-year-old John Hewetson, formerly of St Bees School in Cumberland, arrives at the miners' training centre in Swinton, Lancashire.

January 1944

Lockheed P-38L Lightnings being assembled at an RAF base in England. These aircraft were used to escort and protect bombers during raids on occupied Europe.

19th February, 1944

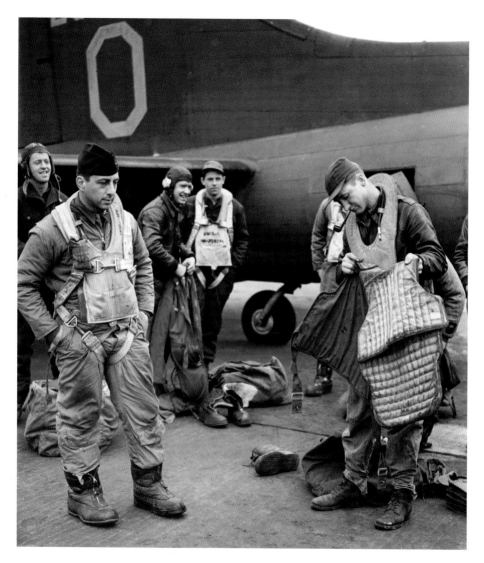

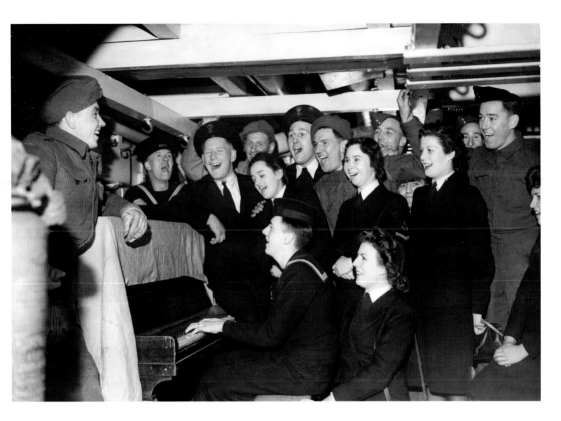

Left: A waist gunner of the US Eighth Army Air Force dons his armoured jacket before boarding a B17 Flying Fortress for a bombing raid on occupied France. (Waist gunners were positioned in the central section of the aircraft; compared to nose gunners and tail gunners.)
c.1944

Sailors and soldiers having a sing-song on a British troop ship.
27th February, 1944

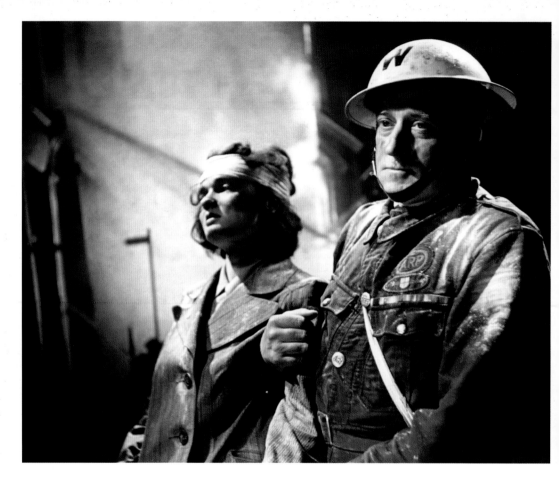

The main job of Air Raid Precautions (ARP) wardens was to enforce the blackout, ensuring that there were no lights on that might help an enemy plane to orient itself or locate its target. However, when called upon they also offered assistance to bomb victims.
March 1944

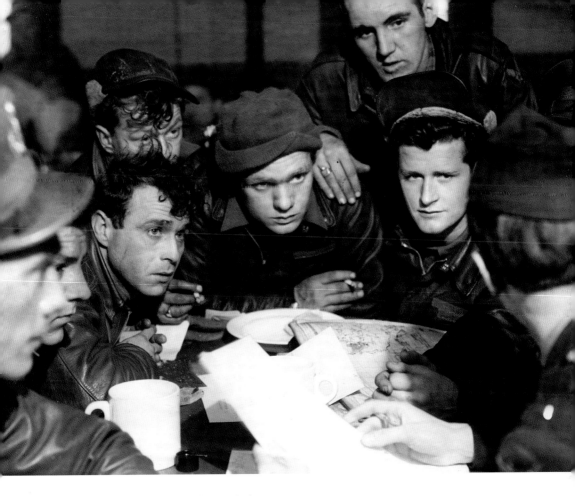

Pilots of the US Eighth Air Force being debriefed by an intelligence officer after a daylight raid on occupied France.
21st March, 1944

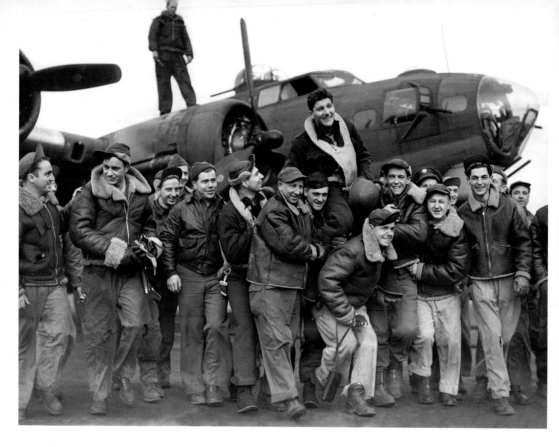

Captain Bender of California celebrates with
crew members of the US Eighth Army Air
Force after completing his 25th mission.
21st March, 1944

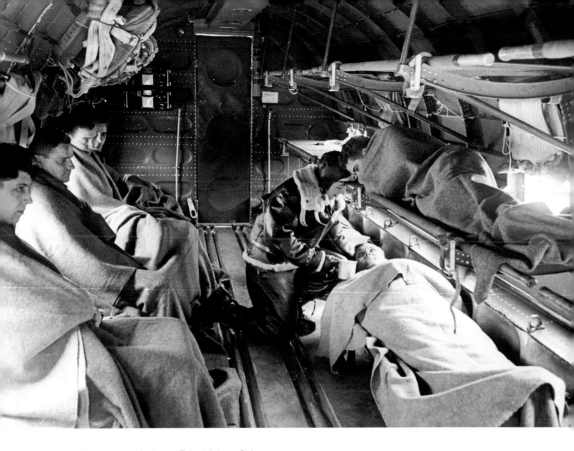

Second Lieutenant Kathryn Friedrich, a flying nurse of the USAAF Ninth Troop Carrier Command, tends to a patient on board a C47 Skytrain Dakota aircraft following a mission to get sick patients from outlying posts.
c.1944

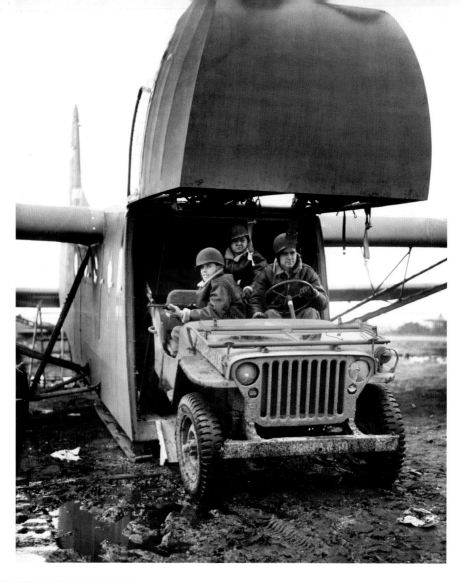

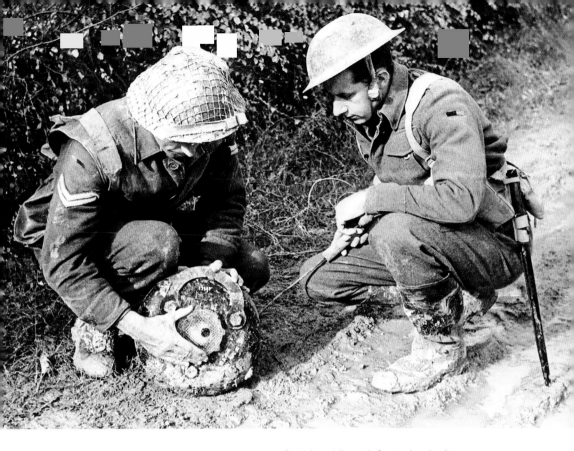

British soldiers defuse a land mine.
6th April, 1944

Left: As part of the preparations for D-Day, the United States sent England hundreds of packing cases containing Waco CG-4 gliders, each of which themselves contained a Willys jeep.
25th February, 1944

New development: WAAFs learn how to reel wet cine film onto drying drums.
8th April, 1944

A British military policeman checks a woman's identity card before allowing her to proceed onto the promenade at Torquay, Devon, which was a War Department (WD) Restricted Area. In the background is a US Army security policeman.
28th April, 1944

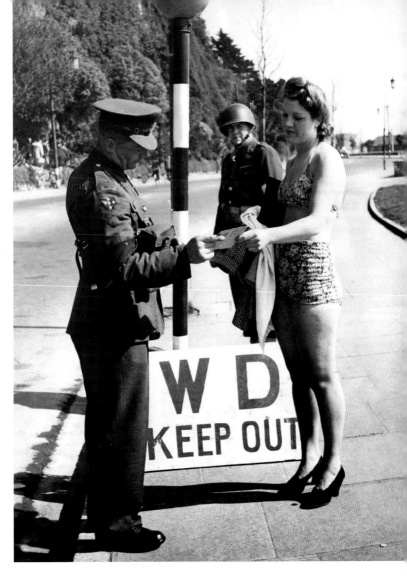

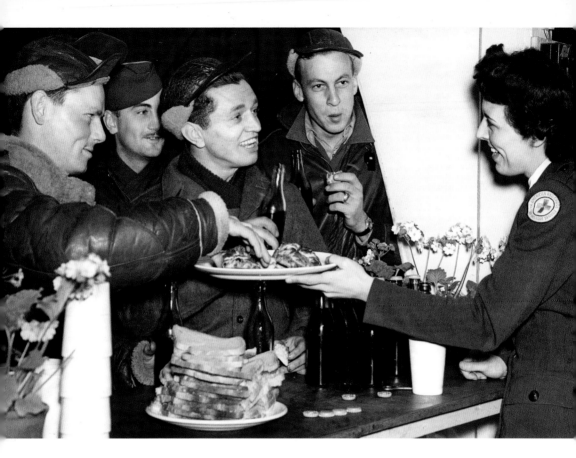

After a bombing raid on Germany, the crew of an American B17 Flying Fortress are welcomed back to England by a Red Cross girl serving food in the mess of their base.
28th May, 1944

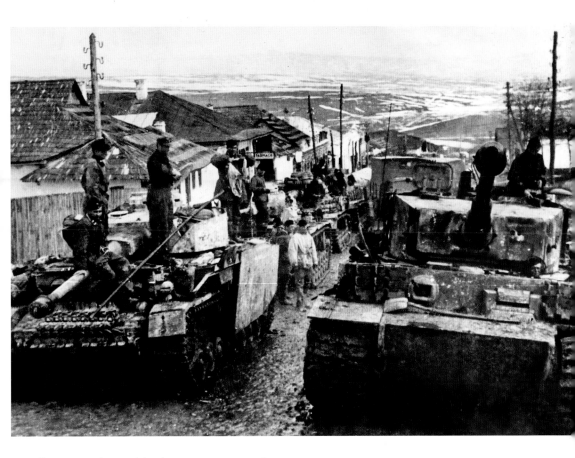

German tanks rumble along a country road
in Romania.
May 1944

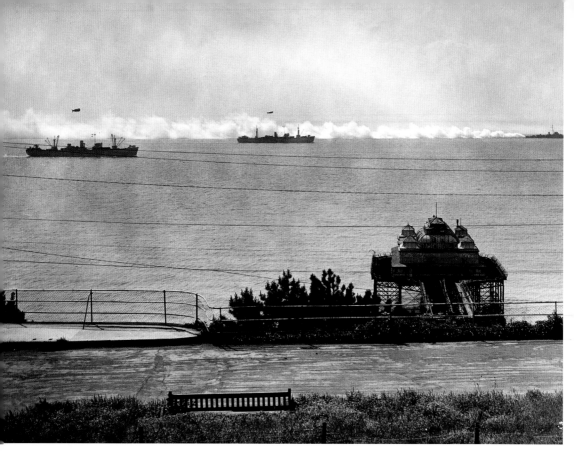

The moment we've all been waiting for: part of the British invasion fleet bound for the Normandy beaches seen here on the morning of D-Day from the cliffs overlooking Folkestone, Kent. Royal Navy destroyers lay a smoke screen to hide the fleet from observers on the French coast.

6th June, 1944

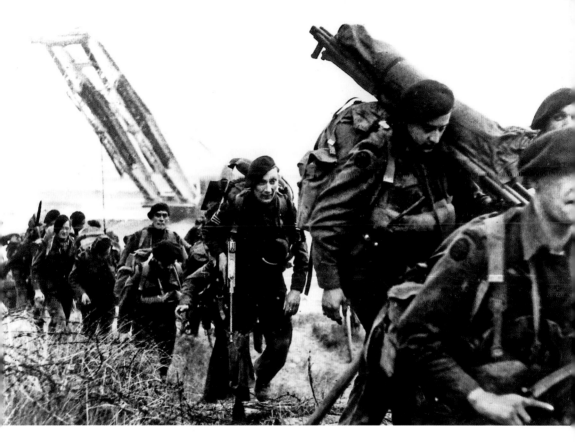

Royal Marine commandos advance inland
after landing on the beaches of Normandy.
6th June, 1944

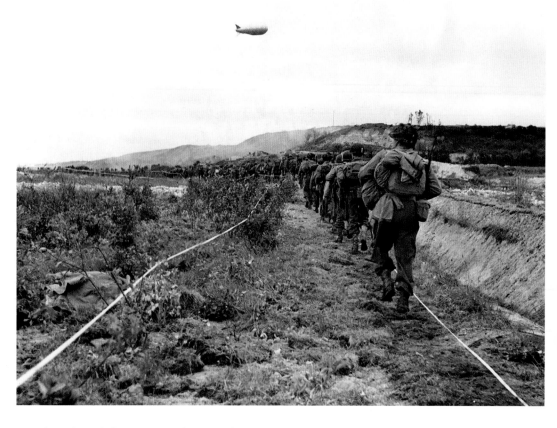

American infantrymen advance along a taped path through a German minefield after their beach landing in Normandy.
1944

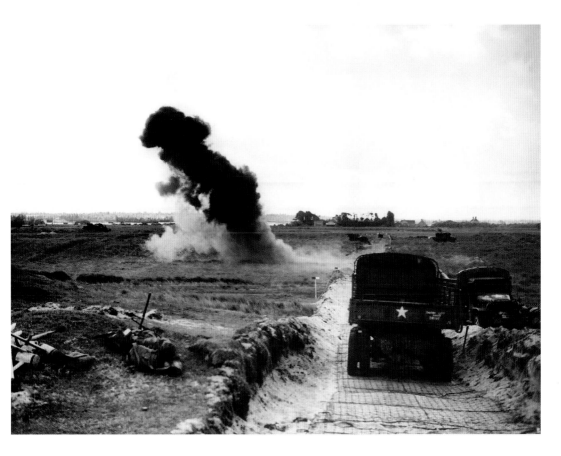

531st Engineer Shore Regiment detonate
German land mines to clear the way for
Allied advance through France.
June 1944

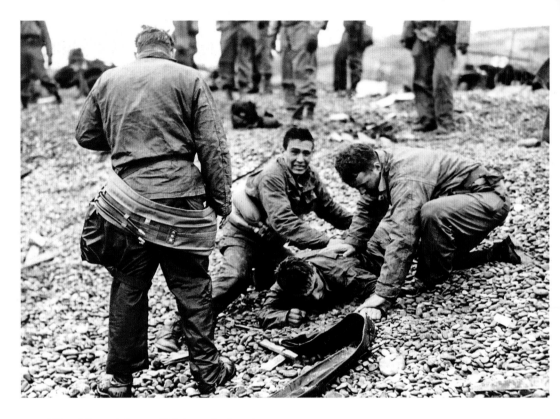

US soldiers giving artificial respiration to a comrade who nearly drowned during the beach landings in Normandy.
6th June, 1944

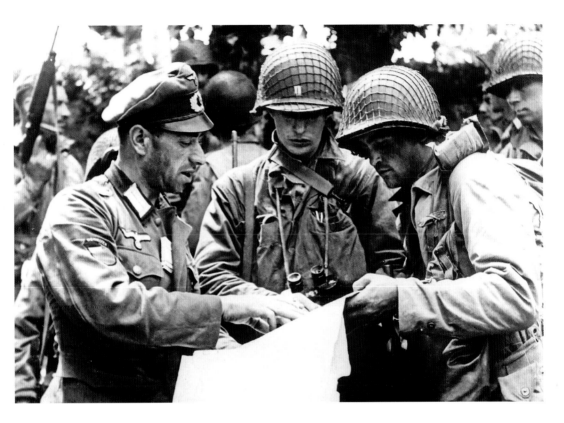

A captured officer of the German
Wehrmacht – a Georgian – explains the
details of a military map to US officers from
the Allied Expeditionary Force that made
the initial landings in northern France.
6th June, 1944

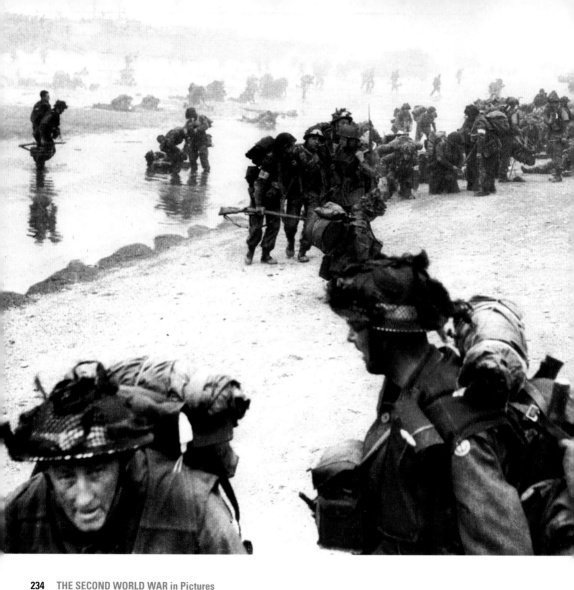

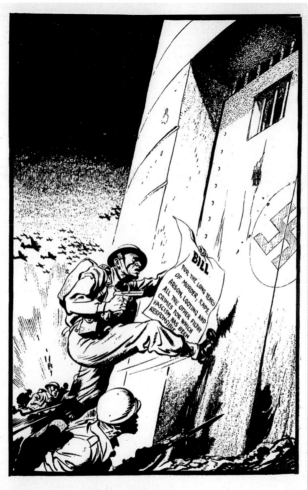

The Hour of Reckoning. (June 7, 1944)

Far left: The Allied landings on D-Day took place along a 50-mile (80km) stretch of the Normandy coast at five beachheads, codenamed Utah, Omaha, Gold, Juno and Sword.
6th June, 1944

Left: A cartoon from a British newspaper the day after D-Day.
7th June, 1944

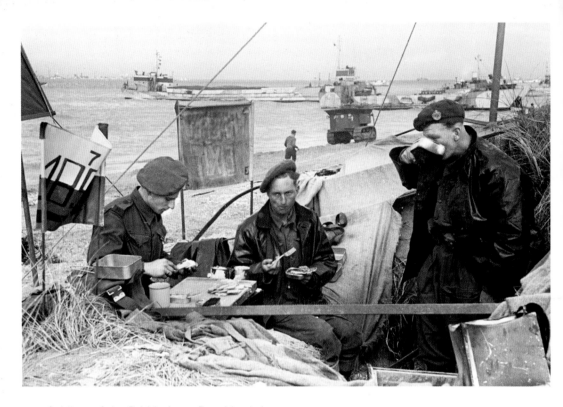

Soldiers of the British Army Royal Logistics
Corps enjoy a cup of tea and a spot of lunch
in between offloading reinforcements on
Gold Beach, Normandy, in preparation for
the big push to Caen.
16th June, 1944

Right: Keep calm and carry on. A woman
tries to keep life as normal as possible amid
bomb damage at New Cross after air raids
on London.
19th June, 1944

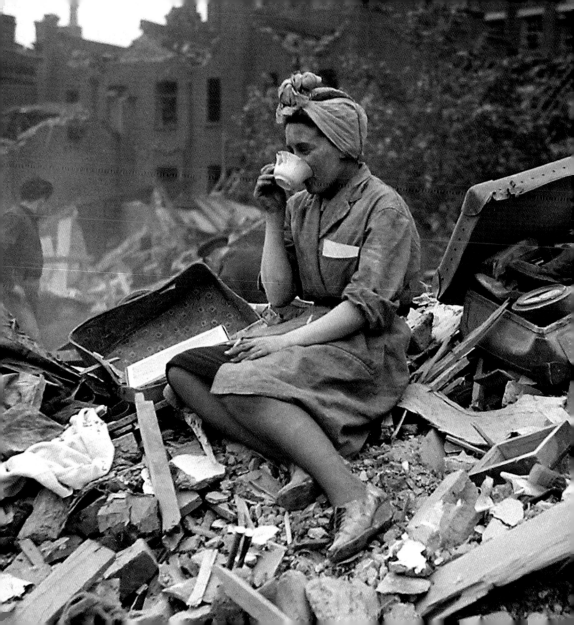

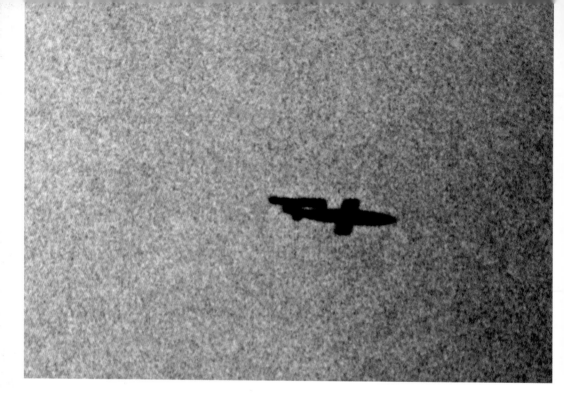

A V-1 flying bomb on its way to Hampstead, North London. The Germans had first used weapons of this type against England 10 days previously, and Londoners quickly learned that the Doodlebugs, as they called them, were safe for as long as you could hear their motors. It was when their engines cut that you were in trouble, because then they would fall from the sky and explode on landing.

23rd June, 1944

Right: Royal Navy ships bombard the enemy-occupied French port of Cherbourg in support of US forces engaged in the battle for the city.

25th June, 1944

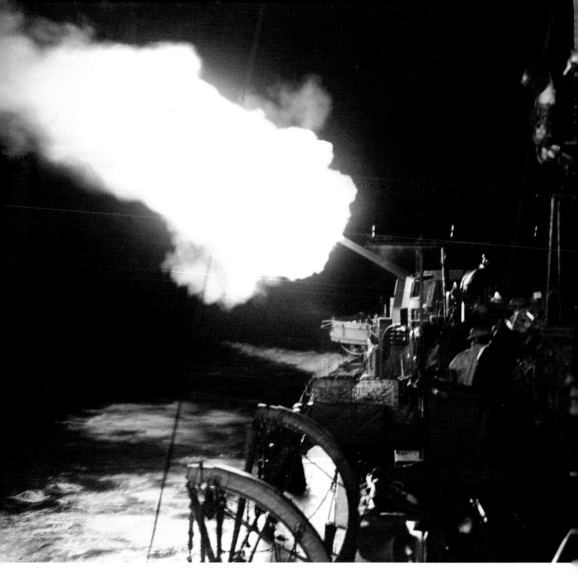

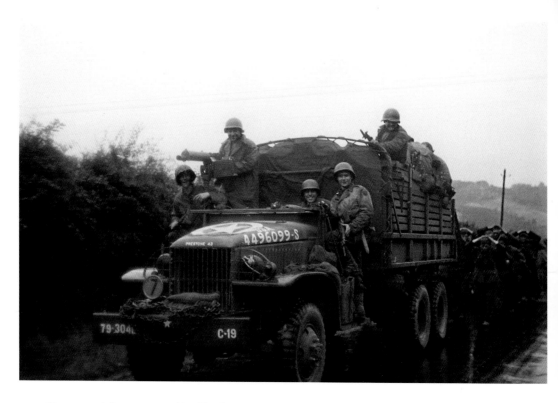

German soldiers captured in Cherbourg are
escorted to camp by Allied forces.
30th June, 1944

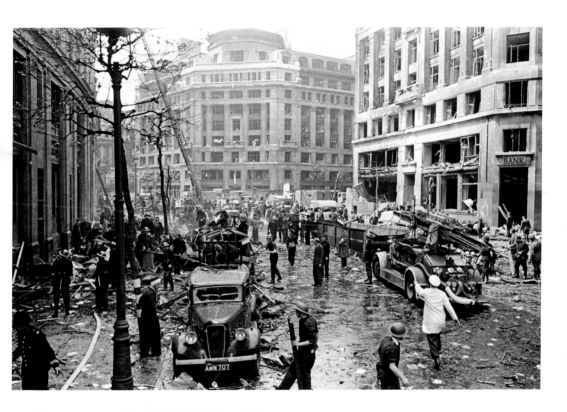

Damage caused by a V-I that fell outside Bush House and the Air Ministry in London's Kingsway.
30th June, 1944

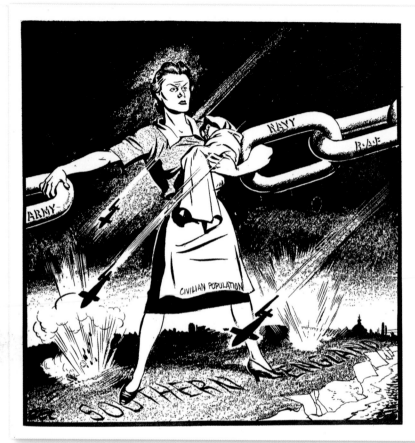

The end approached. Hitler launched his flying-bombs in swarms on battered South-eastern England. But London could still take it.

(July 4, 1944)

61

This cartoon reflects the mood of the hour: the British had suffered greatly, but there was no way they would be defeated.
4th July, 1944

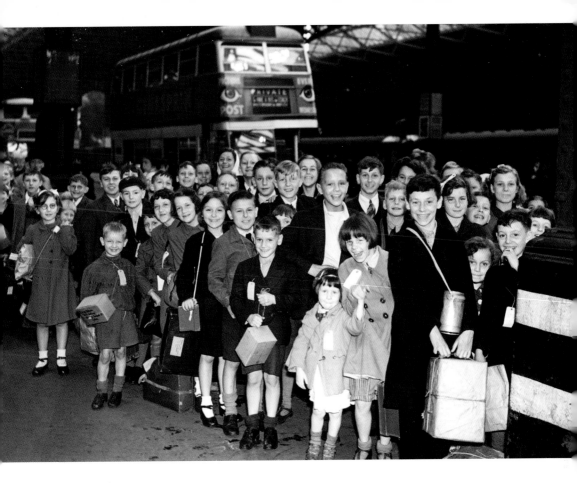

Children at a London railway station preparing to leave for the safety of the countryside, away from the menace of the Doodlebugs.

6th July, 1944

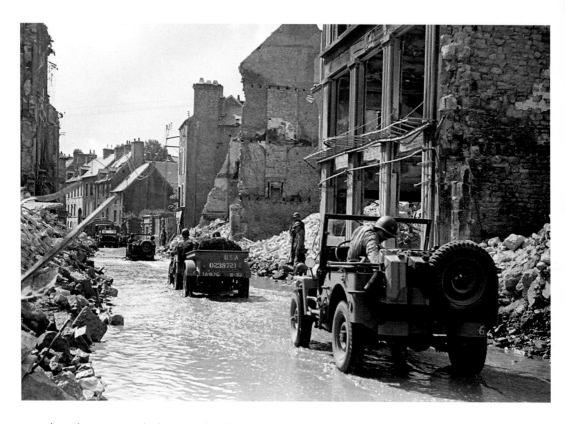

American troops in jeeps make their way
through a bomb-damaged Normandy town.
5th July, 1944

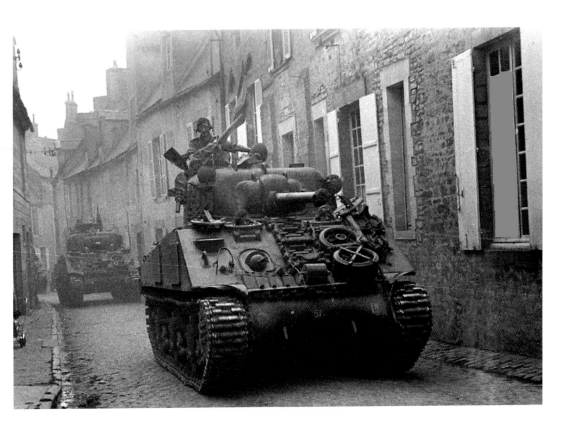

British troops in Sherman tanks roll
through the narrow cobbled streets of a
Normandy town.
5th July, 1944

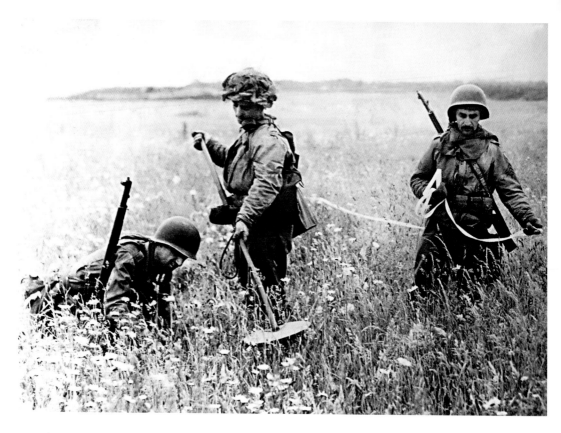

American soldiers sweep a field in northern France for landmines and booby traps left by the retreating Germans.
15th July, 1944

Right: French children play in a pool on the beach at Arromanches while supplies are unloaded from an Allied supply ship in the background.
23rd July, 1944

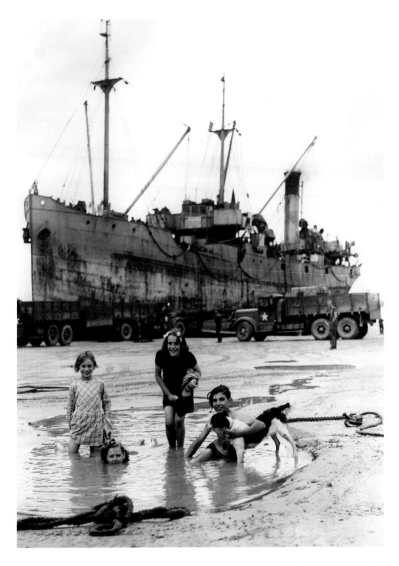

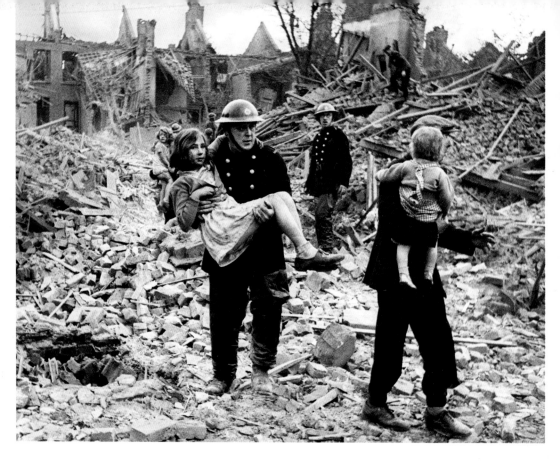

Firemen of the National Fire Service (NFS) carry stunned children from shattered homes and shelters following a German Doodlebug attack.
24th July, 1944

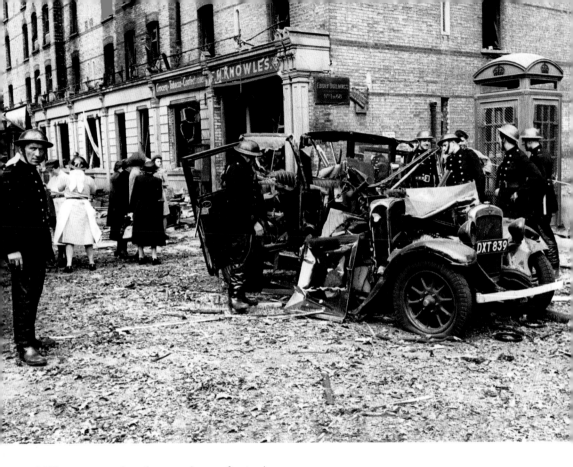

NFS men examine the wreckage of a taxi cab after a V-1 hit on Ebury Street near London Victoria Station.

28th July, 1944

French families return to their homes in Falaise, Normandy, after the Allies liberated the town in an intense battle that cost the lives of 10,000 Germans; 50,000 more were taken prisoner.

August 1944

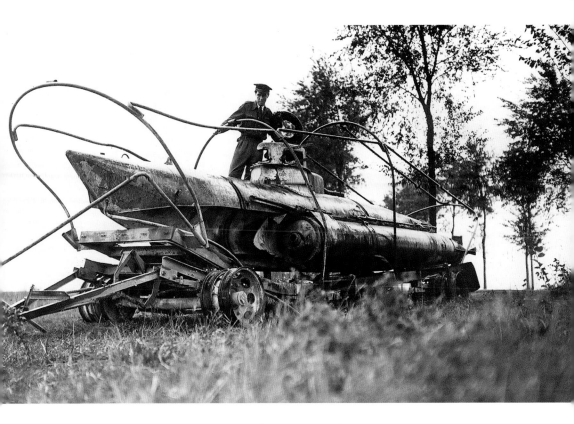

A British officer examines a captured German one-man submarine.

8th August, 1944

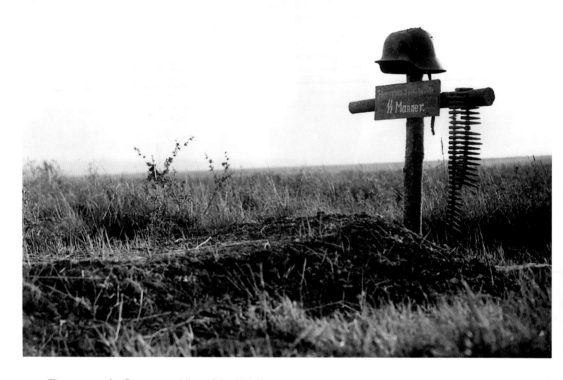

The grave of a German soldier of the Waffen
SS in Normandy.
16th August, 1944

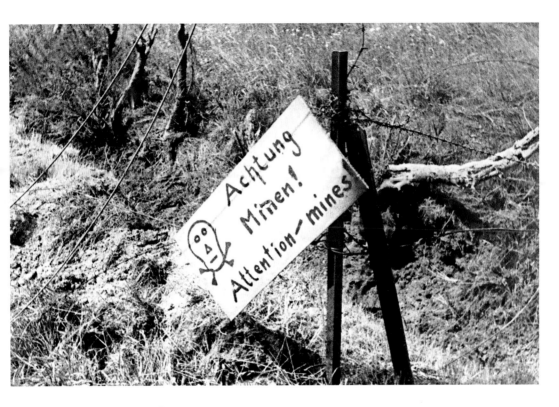

Warning sign found by Canadian soldiers on
their arrival in France.
17th August, 1944

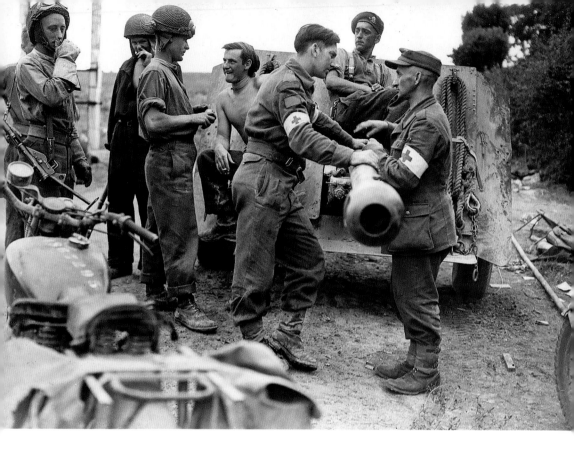

British and German Red Cross personnel meet over a howitzer in Normandy.
25th August, 1944

Right: The funeral of two NFS men killed on duty when their station at Abbey Road, London, was partially demolished by a V-1 flying bomb.
30th August, 1944

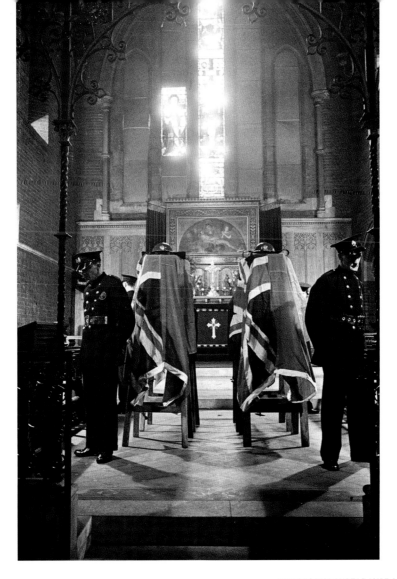

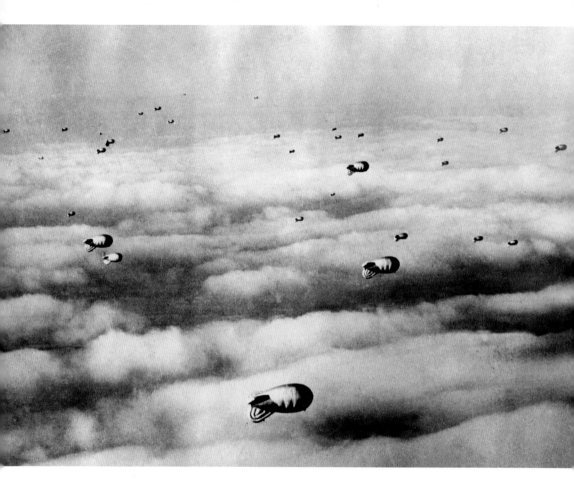

A section of the balloon defences put up by the RAF as protection against German flying bombs.
September 1944

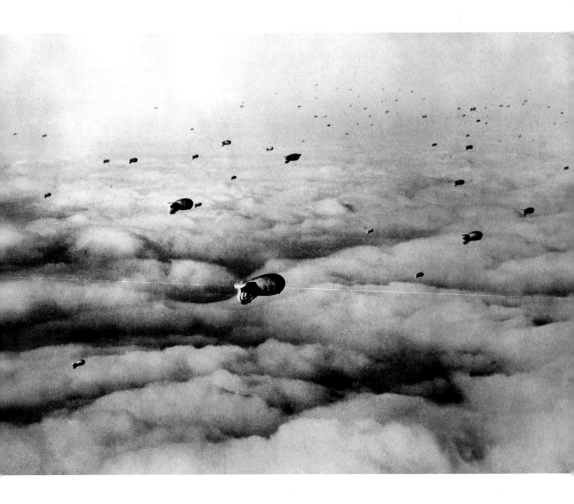

A British armoured division enters Valkensenswaard, the first village in the Netherlands to be liberated from Nazi occupation.

20th September, 1944

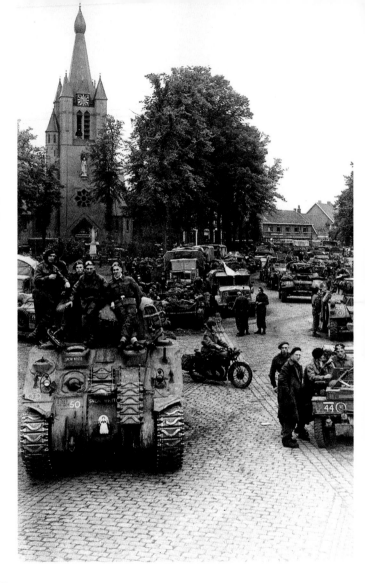

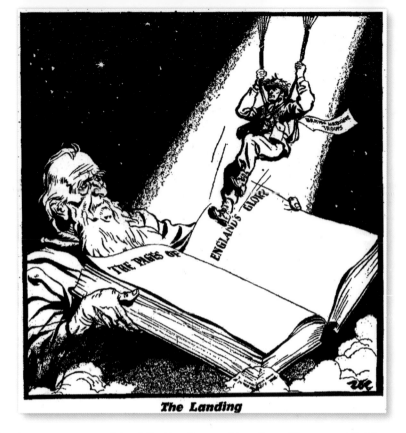

The Landing

Following the great success of the Allied landings and invasion of France and Belgium, progress had slowed in the face of strong defensive positions taken up by the German army in Holland. In order to break the deadlock and hasten the end of the war, the Allies launched Operation Market Garden, an airborne assault on Arnhem aimed at seizing territory and, crucially, bridges, to facilitate the movement of troops and equipment. In the event it was a failure; German resistance was stronger than expected and thousands of Allied troops were killed or captured.

29th September, 1944

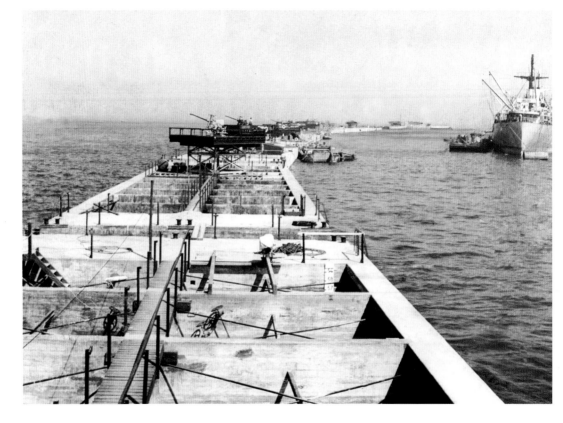

A liberty ship (a US-built cargo vessel) inside the outer wall of a mulberry harbour (one of the floating landing stages brought across the English Channel to aid the Allied invasion of Normandy) just off Gold Beach at Arromanches.
10th October, 1944

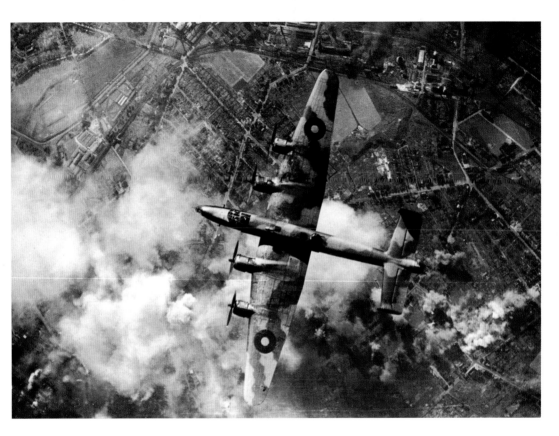

In a daring daylight raid, an RAF Halifax
bombs a synthetic oil manufacturing plant in
the German Ruhr Valley.
20th October, 1944

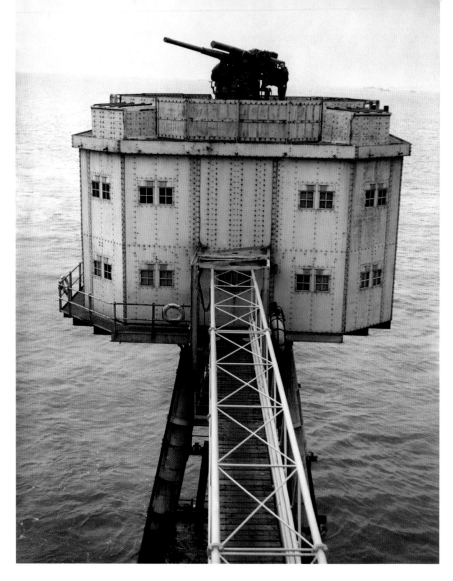

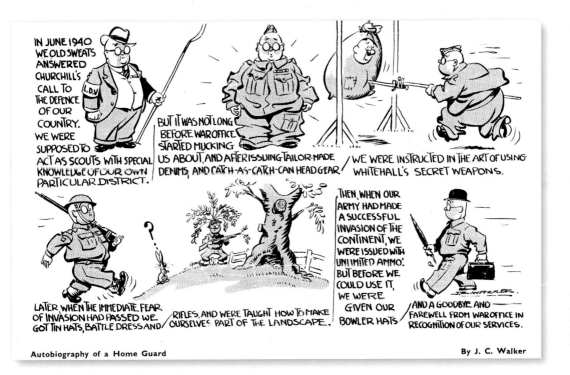

Autobiography of a Home Guard

By J. C. Walker

Left: An ack-ack gun mounted on top of one of the forts built around the coast of England to protect against invasion.
November 1944

Published on the day after the Home Guard was stood down (the fear of invasion had now definitely passed), this cartoon by J.C. Walker provides a satirical account of the force that had been called the Local Defence Volunteers until people began to joke that the initials 'LDV' stood for 'Look-Duck-Vanish', whereupon the name was changed to the Home Guard.
4th December, 1944

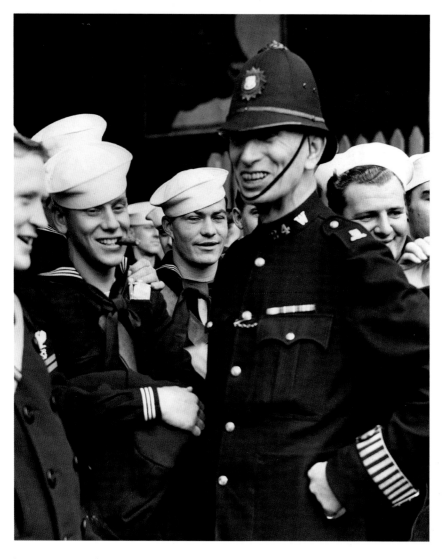
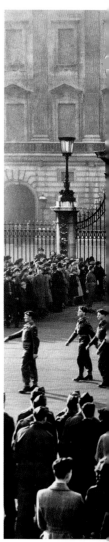

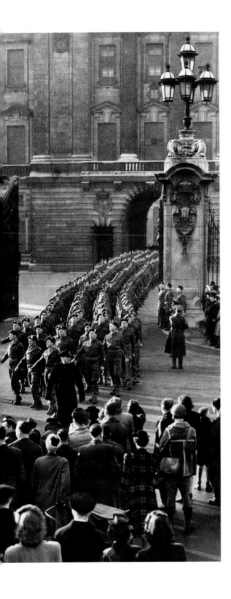

Left: A London policeman shares a joke with a group of American sailors.
c.1944

Four hundred men of the Airborne Division who took part in the ill-fated Arnhem operation (see *page 259*) march away from Buckingham Palace after their special investiture by King George VI.
6th December, 1944

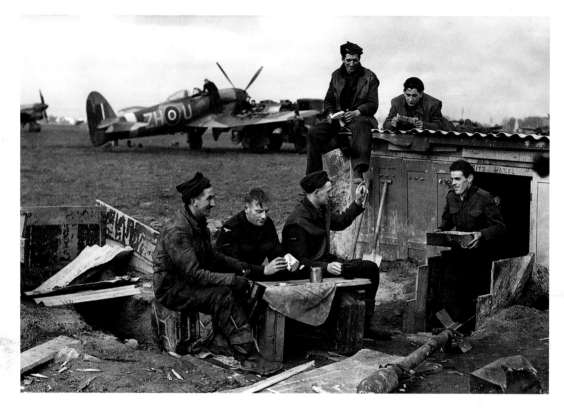

RAF ground crew relax outside their 'Blitz Hotel'. In the background is a Hawker Typhoon.

7th December, 1944

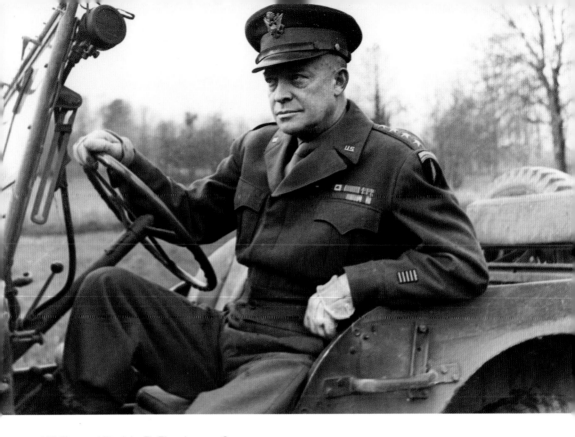

US General Dwight D. Eisenhower, Supreme Allied Commander in Europe, in a jeep on the way to deliver his Christmas message to one representative soldier from each of the allied countries.

20th December, 1944

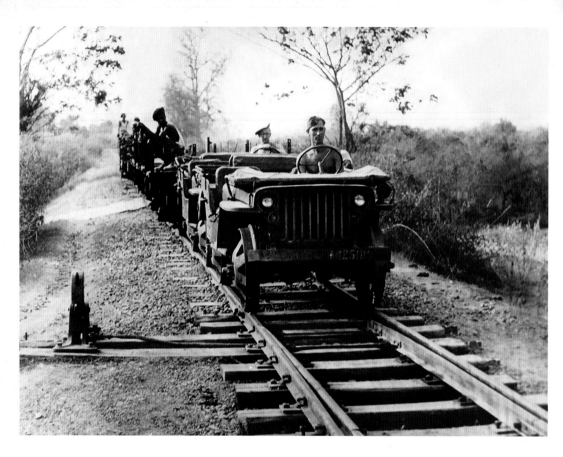

The war in Asia: an Allied jeep railway in Burma.
c.1944

Right: Sherman and Lee tanks make their way along the dried-up bed of the Sipadon Chaung monsoon river in central Burma.
c.1945

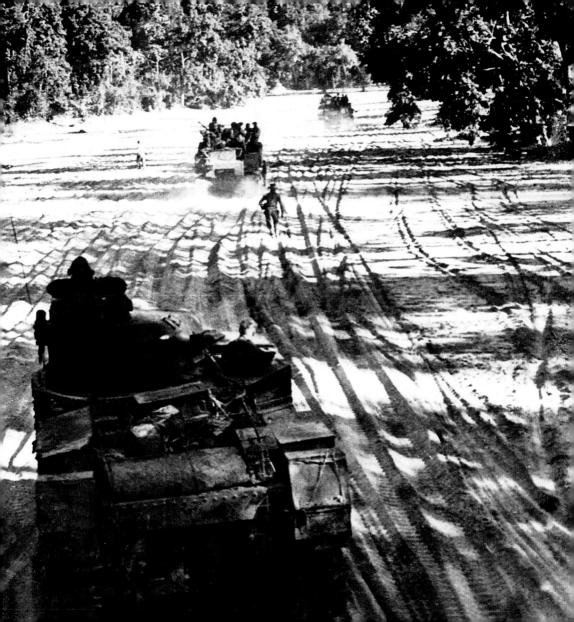

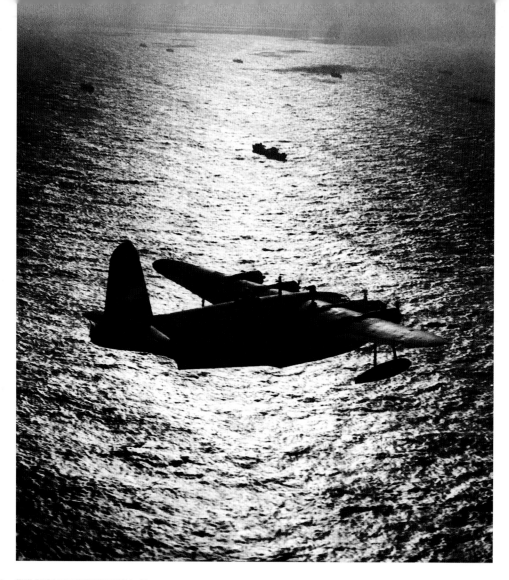

Engineer vehicles of the US First Army carry pontoons towards the River Rur, a tributary of the Meuse in Germany.
c.1945

Left: A Short Sunderland flying boat of RAF Coastal Command patrols above an Atlantic convoy 500 miles (800km) southwest of Ireland.
c.1945

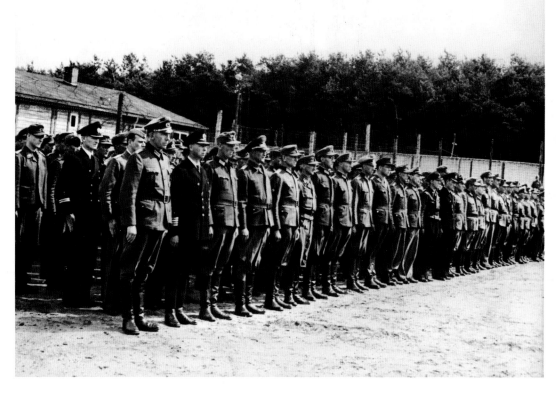

Captured German officers in a prisoner-of-war camp in England.
c.1945

Right: A photo call for the three Allied leaders at the start of the eight-day Yalta Conference, in which they determined the shape of postwar Europe. (L–R) British Prime Minister Winston Churchill; US President Franklin D. Roosevelt; Soviet leader Joseph Stalin.
4th February, 1945

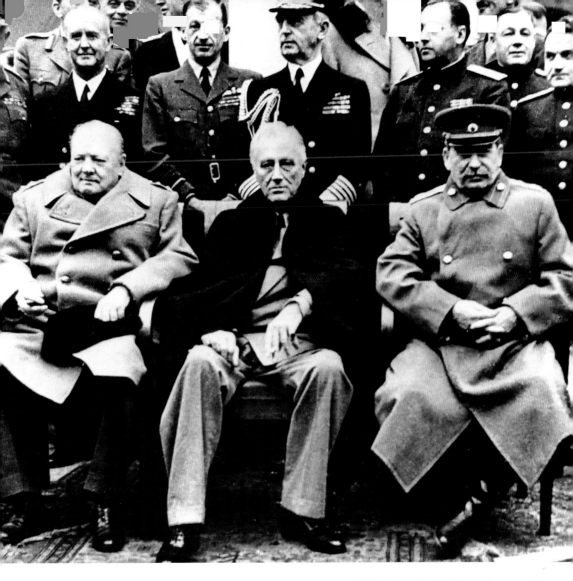

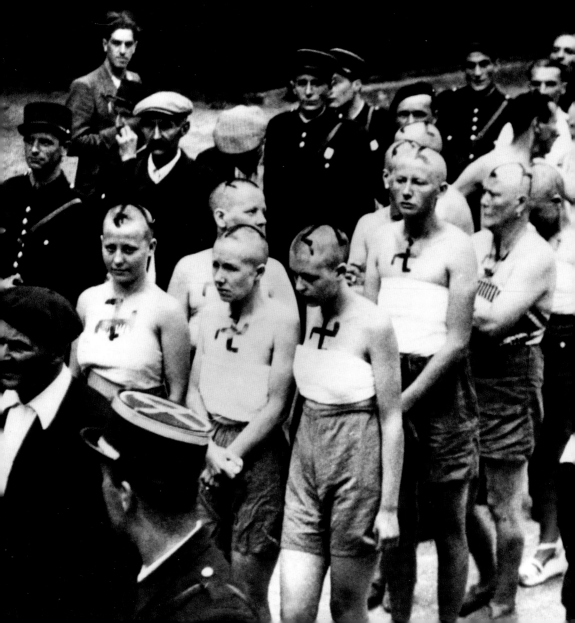

French men and women accused of collaborating with the Germans during the occupation are marched through the streets of Paris in the early days of the liberation. They have had their heads shaven and are partially stripped.

5th February, 1945

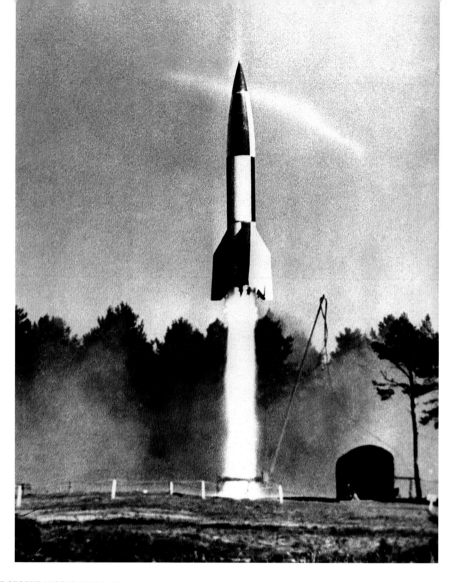

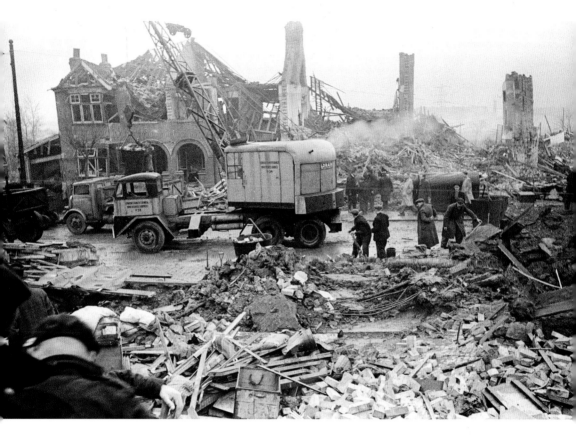

Left: After the V-1s came the V-2s, developed by German scientist Werner von Braun. More than 3,000 of them were launched; most were aimed at London but later the Nazis turned their attention to Antwerp, Belgium.

c.1945

Damage caused by a V-2 that fell in Chingford Road, Walthamstow, London and hit a surface shelter, killing eight people and causing serious injuries to many residents in surrounding houses.

8th February, 1945

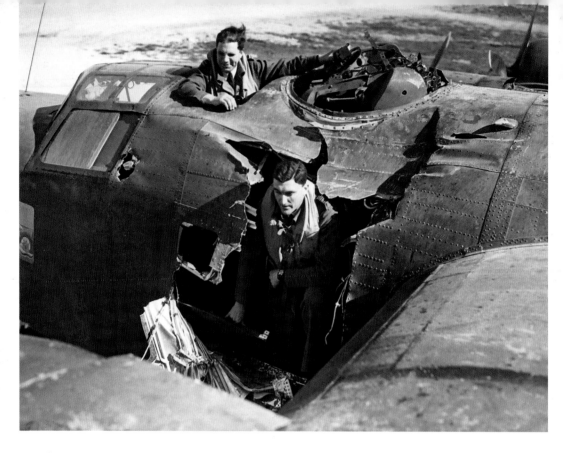

Crew examine the jagged hole in a USAAF Consolidated Liberator B25 bomber after a bombing mission over enemy territory.
6th March, 1945

Right: A Boeing B17 Flying Fortress of the USAAF Eighth Air Force 3rd Bombardment Division drop their bombs on 2,000 freight trucks carrying military supplies at Frankfurt marshalling yards.
9th March, 1945

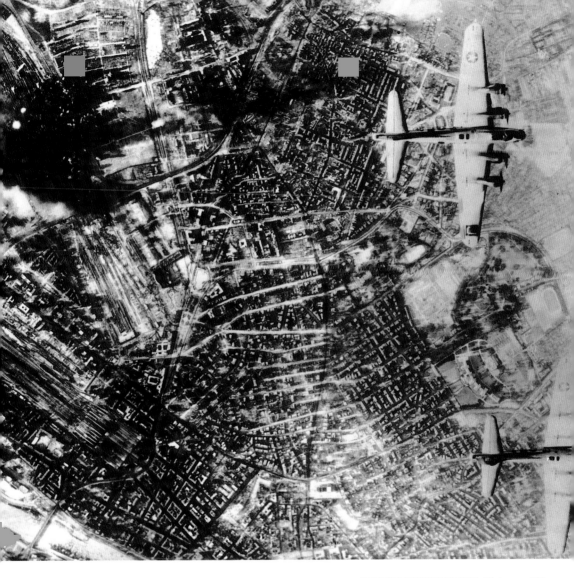

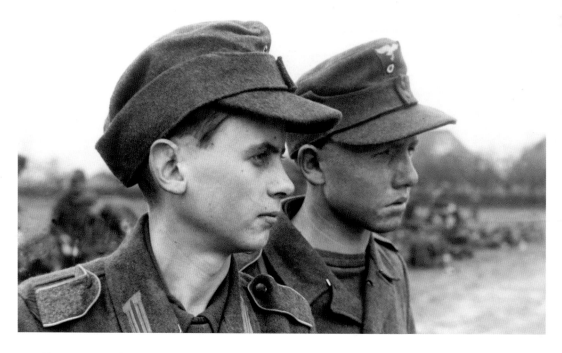

Two teenage German prisoners, both with less than 12 weeks' training, who were captured with over 8,000 others as Field Marshal Montgomery's troops crossed the River Rhine.

27th March, 1945

Right: As the Allies advance, German women are forced to do their washing in cold water in a street. Beside them is a knocked-out Wehrmacht scout car.

3rd April, 1945

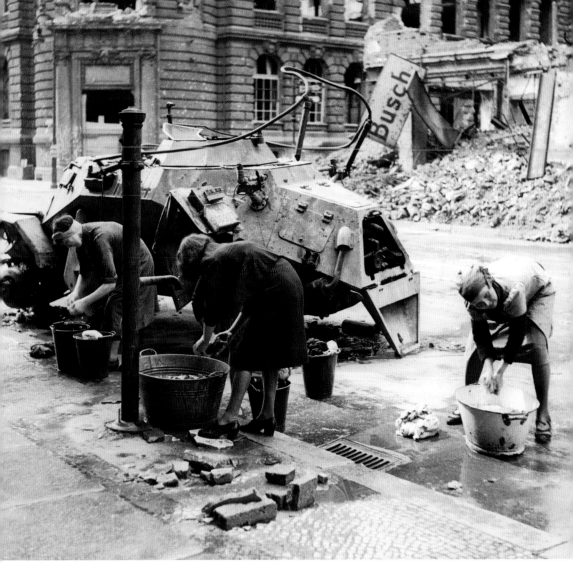

THE SECOND WORLD WAR in Pictures

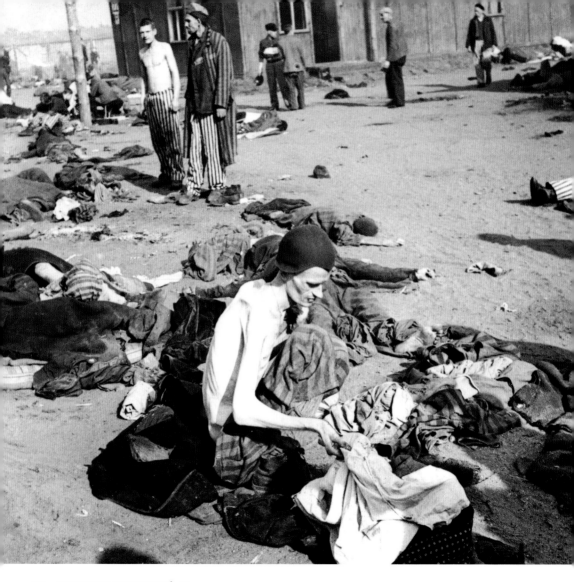

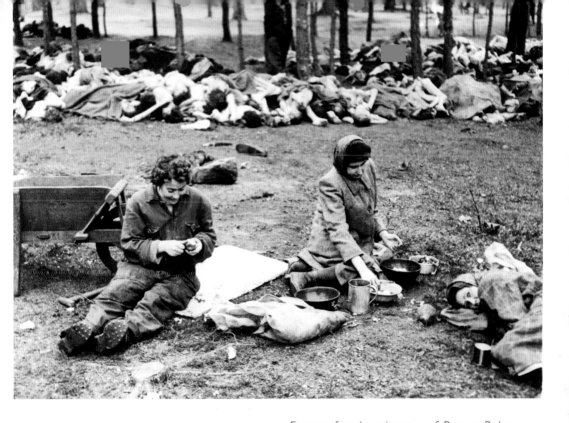

Former female prisoners of Bergen-Belsen concentration camp peel potatoes in front of piles of dead bodies.
21st April, 1945

Left: And then came the greatest horror, the discovery of the concentration camps. Here an inmate of Bergen-Belsen delouses his clothes after liberation by the British 11th Armoured Division.
21st April, 1945

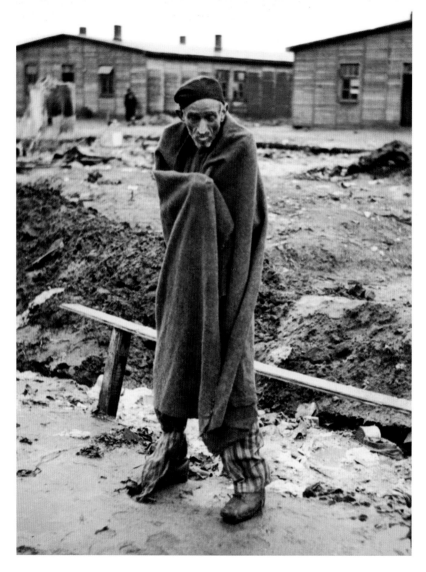

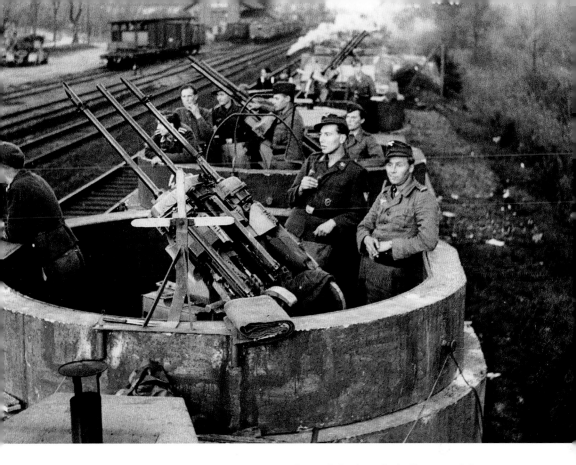

Left: A political prisoner, a Hungarian Jew, in the Stalag X-B prisoner-of-war camp near Sandbostel in Germany after it was liberated by the British Guards Armoured Division.
29th April, 1945

One of the last-ditch German defences: an anti-aircraft train.
May 1945

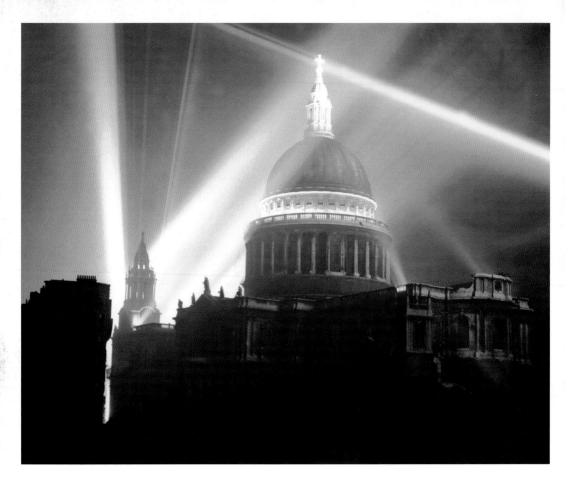

Searchlights to celebrate the end of the need
for searchlights: St Paul's Cathedral is floodlit
on Victory in Europe (VE) Day.
8th May, 1945

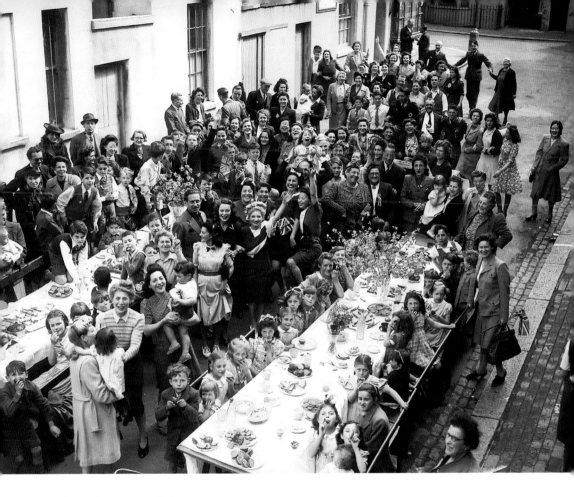

The following Sunday, Britain rejoiced on its
day off work. This is a street party in London.
12th May, 1945

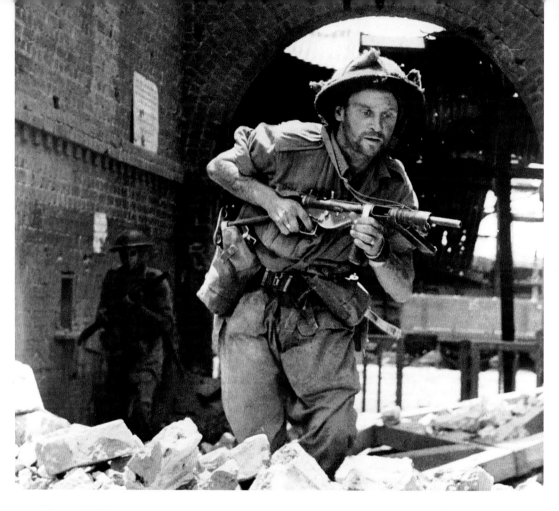

The war in Europe was over, but in Asia the conflict raged on. Here British soldiers scour the ruins of Yamethin railway station in Burma for Japanese suicide attackers.
May 1945

Two British soldiers inspect one of the insanitary wooden cell blocks in which the Japanese incarcerated special prisoners, airmen, fifth columnists and spies.
1st July, 1945

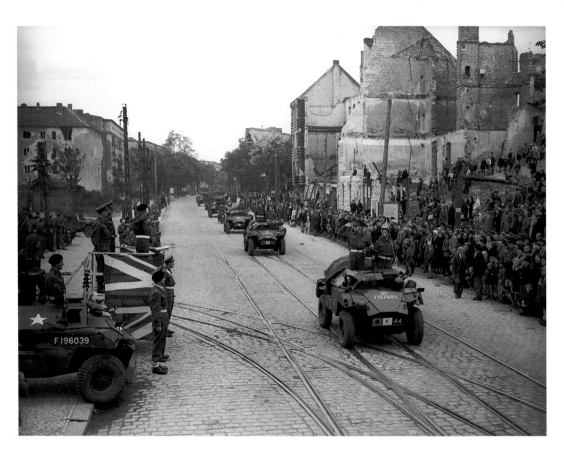

Seventh Armoured Division – the proudly self-styled 'Desert Rats' (veterans of El Alamein) – were the first British troops to enter Berlin after the Second World War. Here they are saluting their General Officer Commanding (GOC), Major-General Lewis Lyne.
7th July, 1945

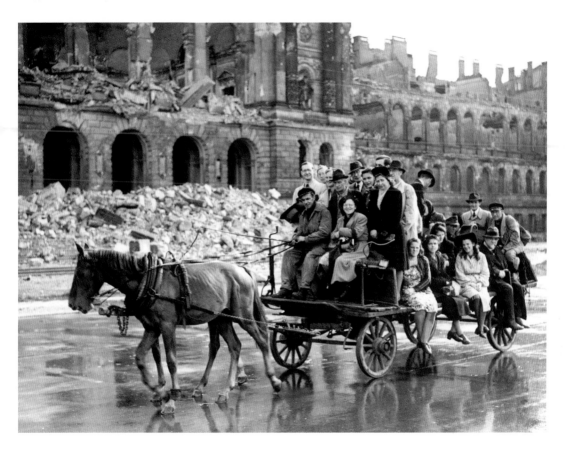

Local Berliners make their way home in a horse drawn cart with the ruins of the Engineering college behind them.
9th July, 1945

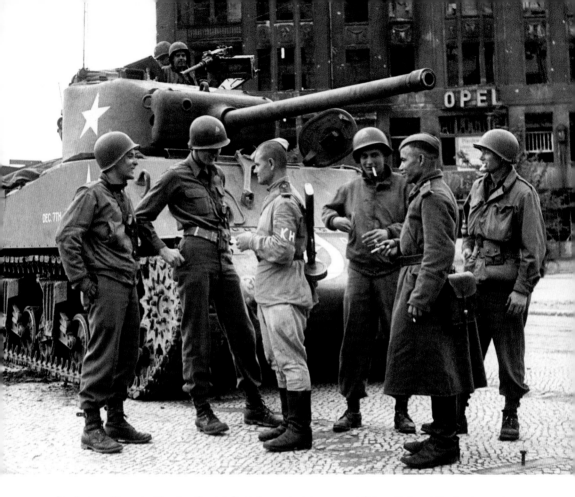

Berlin was liberated by the Soviet Red Army, but because of the city's particular importance, both economically and symbolically, it was subsequently divided between all the main Allies. Here Russian troops talk to American servicemen as US tanks park up in the German capital. **9th May, 1945**

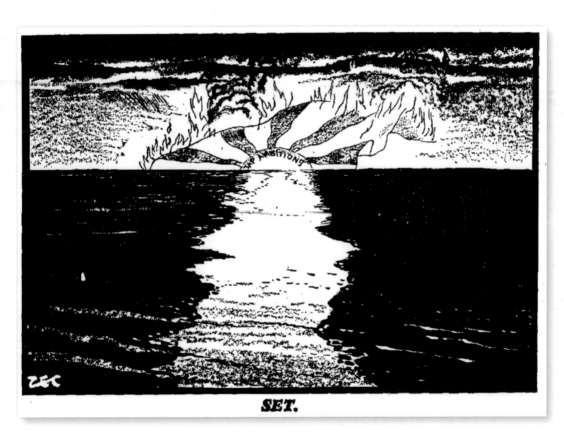

SET.

A Zec cartoon marking the end of the Second World War, which came on 10th August when the Japanese surrendered after the United States had dropped atomic bombs on Hiroshima (6th August) and Nagasaki (8th August).
11th August, 1945

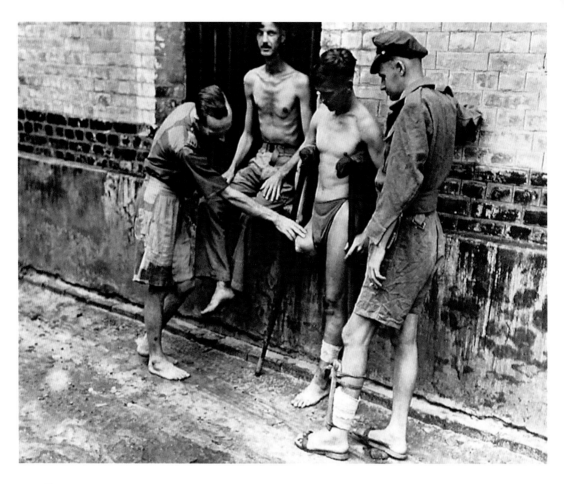

The conditions in Japanese prisoner-of-war camps were another horror that did not emerge until after the conflict. This photograph shows British Commonwealth soldiers emaciated and clothed in rags.

c.1945

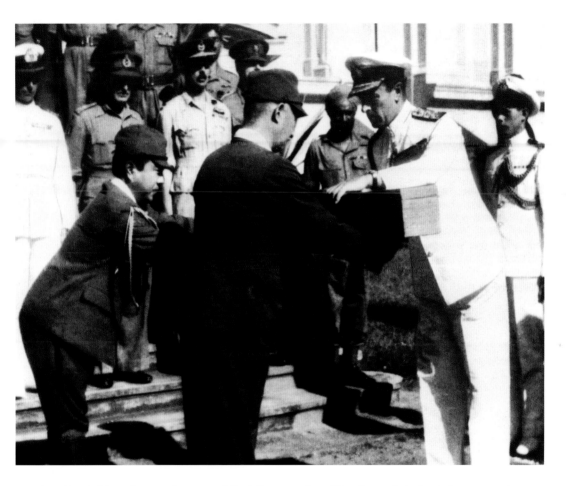

Lord Louis Mountbatten, Supreme Allied Commander of Southeast Asia, formally accepts the Japanese surrender at the end of the Second World War.
September 1945

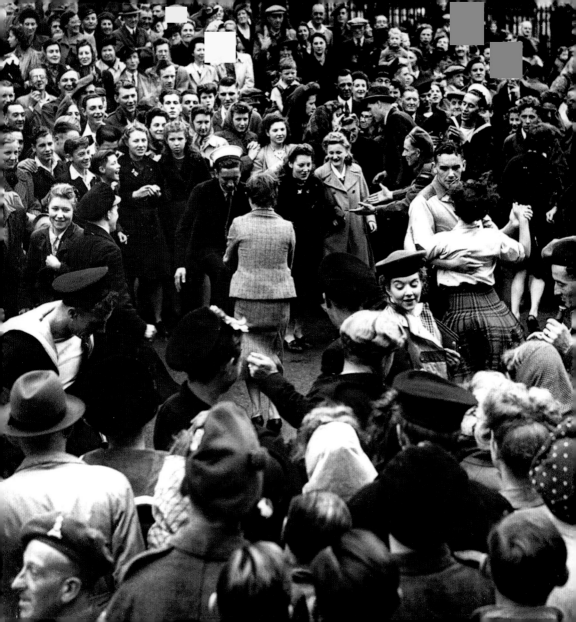

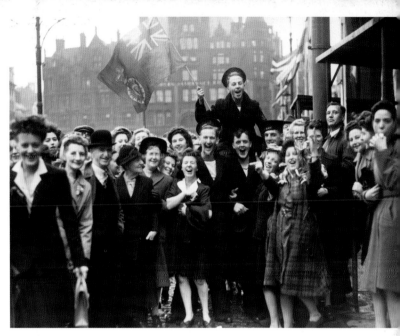

Crowds in Albert Square, Manchester, celebrate Victory in Japan (VJ) Day.
15th August, 1945

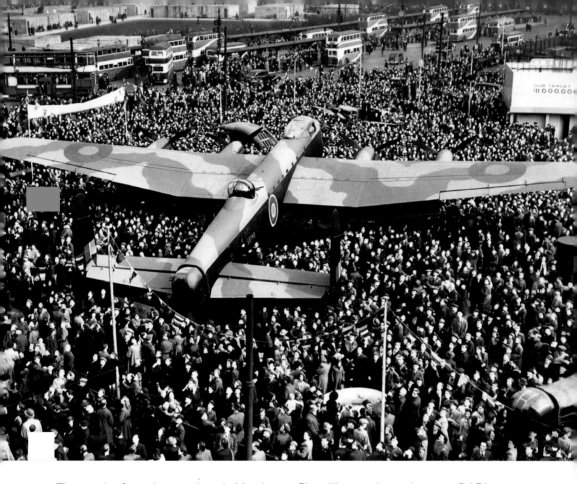

Thousands of people turned out in Manchester Piccadilly to welcome home an RAF Lancaster bomber, the construction of which had been funded by War Savings *(see pages 180-181).*
24th August, 1945

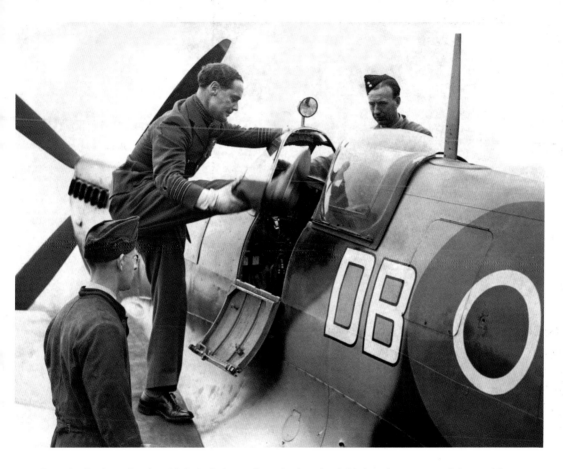

Douglas Bader – Battle of Britain fighter pilot who lost both his legs in a prewar flying accident – enters the cockpit of a Spitfire before the RAF Thanksgiving Flight over London.
15th September 1945

The publishers gratefully acknowledge Mirrorpix, from whose extensive archives the photographs in this book have been selected.

AMMONITE
PRESS